Santiago Calatrava

Santiago Calatrava
Secret Sketchbook

Edited by Mirko Zardini
Photographs by Paolo Rosselli

THE MONACELLI PRESS

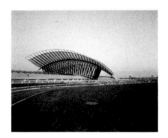

Cover: Satolas Station, Lyon
Back cover: See page 33

First published in the
United States of America in 1996 by
The Monacelli Press, Inc.,
10 East 92nd Street, New York, New York 10128.

Library of Congress Catalog Card Number: 95-81809
ISBN: 1-885254-33-4

Printed and bound in Italy

Translated from the Italian by Vittoria Di Palma

Editorial coordination by Guia Sambonet
Designed by Giorgio Camuffo/Camuffo Design
Model photographs by Heinrich Helfenstein

Introduction *Pierluigi Nicolin*

The document presented in this book can be defined as unique.

I say this thinking in particular of the task of presenting original sketches and notes in order to express the synthesis of an experience that is not yet over, and of all the critical problems such a position entails. In this case we must also take into consideration the fame of the document's author, gained in a field whose very nature must be discussed. Before addressing this, however, we can immediately highlight one of the goals of this sketchbook: to end a discussion about the nature of its author's work. It seems to me that on this point the notebook offers a rather explicit indication; Santiago Calatrava presents himself to his critics as an artist. I do not see why we should not believe him, even if numerous questions raised by a body of work that ranges from engineering to architecture to sculpture remain unanswered.

Faced with such wide-ranging work, one's first response tends to be to try and keep things separate by dividing the various works into genres. The notebook, however, does exactly the opposite, and I believe that is a good thing, even if it complicates the act of interpretation.

Another unique aspect of the notebook is the nature of the reconnaissance represented by its sketches and notes. The notebook documents a voyage into the past undertaken by retracing different paths within the body of work without paying attention to either rigid temporal divisions or distinctions between genres. The lightning-quick sketches of figures and objects—primarily references to works of art and naturalistic details—could have a documentary character or result from analogies and connections discovered only later. The same can be said about singling out details or important aspects in both built works and projects.

Created in only a few months, the document resembles a text of self-defense, as though it were a petition to submit to a tribunal of inquisitors; in this it emanates the fascination of another era. On the other hand, it disarmingly presents itself with all of its contradictions owing to the lack of a rational argument.

Furthermore, recalling certain old stories about the Inquisition, one could even consider the likelihood that such a book-as-confession could be transformed into an incriminating piece of evidence. In fact, the closer we are led to the secret inner workings behind many of the author's works, the more we see the plot thickening, as if the said, the represented, were nothing more than a hint, a chink indicating the existence of a "second voyage" which cannot be recounted in the usual way.

Since this notebook is the product of one of the most prominent figures in contemporary engineering, we must consider it in particular with respect to the lack of literature on the topic in general. Most probably, it is precisely this scarcity of critical literature about engineering that allows a "text" like this one of Calatrava's to be put forth, a situation that makes it a unique and definitely anomalous document.

We must ask ourselves why we do not have a real body of critical texts on engineering, on the techniques that increasingly characterize the transformation of our environment's structures and infrastructures, and whose technical and formal content we end up knowing only approximately at best.

Someone who sets himself the task of discussing this subject in other than technical terms must take into account the lack of related literature and resign himself to the role of a pioneer. At the most we have at hand a few notes by Nervi, Morandi, Torroja, and Felix Candela, we have some memoirs, such as Peter Rice's, we can cite a few aphorisms of Maillart. It is true that contemporary culture has spoken about engineers through the mouths of a few writers such as Musil, or in some notes of Valery's, but most commonly we have the point of view of engineers expressed by architects.

The most famous and influential of these was naturally the point of view expressed by Le Corbusier at the same time that he was outlining his machine aesthetic. For Le Corbusier, the engineer (and the entrepreneur) is the hero of the machine age, the protagonist of a Weberian rationalism with respect to the ends. "The Engineer, inspired by the law

of Economy and governed by mathematical calculation, puts us in accord with the universal law. He achieves harmony."[1] The architect's traditional admiration for engineers can be summed up in one word: calculation. Incomprehensible to the uninitiated, symbol of a world as unknown and obscure as mathematics, calculus ends up by being attributed mystical virtues by architects. It seems to them that in the mysterious and unknown realm of mathematics and higher geometry, a procedure is carried out that emanates the reassuring aura of applied reason.

Notwithstanding a few dissenting voices, such as Eugène Freyssinet's characterization of the overly mathematical and abstract teaching of the Ecole des Ponts et Chaussées—"a machine for boxing in brains from which emerged cowards capable at the most of hiding behind mattresses of mathematical equations"[2]—this cliché remains unchallenged; architects prefer to think of engineers in terms of that fictional character they themselves invented. It is well known that in the French tradition the distinct figures of engineer and architect occupy the opposite ends of a polarized organization—divided once and for all by the separate institutions of the Ecole des Ponts et Chaussées and the Ecole des Beaux-Arts—where the subdivision of labor assigns the artistic work to the architect while the domain of calculation is reserved for the engineer.

Over time such an anachronistic division has been the target of innumerable criticisms, but a real dismantling of the constructed roles has never been attempted. "The concept of structure is at the heart of the production of the engineer-builder, insofar as it was defined from at least the eighteenth century on. Joined to such a key concept is the ideal of economy in the material used, of an exact calculation of the constructional elements. A good engineer is one who knows how to use the minimal means to obtain a given result," affirmed Antoine Picon recently, following in the footsteps of that tradition.[3]

And yet by taking such a point of view as the norm, not only do we find ourselves possessing a limited notion of technology itself, by ignoring both this century's entire technical-scientific development (with its oscillations and its

dangers) and the discussions concerning technology in epistemology and twentieth-century philosophy as a whole, but we would also end up reducing Le Corbusier's position of the 1920s to that of rejecting as superfluous the merely aesthetic combinations of the architect in favor of a supposed law of necessity guiding the working method of the engineer. This point of view also affirms, again taking up an eighteenth-century theme, that by using mathematics the engineer should be able to extract from nature its own laws, thus in a sense transforming nature into machine.

Lucid minds like those of Valery or Le Corbusier sought to disrupt this dualistic scheme in the same way that other artists have made geometric-mathematical precision a means of skirting the shoals of post-impressionism and the various eclecticisms of the early twentieth century. Valery's repeated considerations of Leonardo have this significance and, even if we recognize the echo of a polemic for the sake of it in Le Corbusier's affirmations, the idea of finding an aesthetic concept in the principle of calculation itself, far from a secondary consideration in the fine-tuning of purist aesthetics during the twenties, not only engages in a classical architectural tradition but also has the goal of dismantling the French tradition's dualistic scheme. To abandon Le Corbusier's arguments on the "engineer's aesthetic" and limit ourselves to viewing an unending production of roads, bridges, airports, stations, and industrial buildings as products oblivious to formal concerns, or to see the world transforming itself through the never-ending production of random forms, is nothing more than a sign of our present impotence, which places us in a spiritual condition similar to that preceding Walter Benjamin's reflections on the subject.

On the other hand, many of the statements by engineers about architecture are often of a disturbing banality owing precisely to this rigid separation dating from the eighteenth-century introduction of analytical calculus into building science, through which the classical theory of building construction has come to be dismantled.

It is in reference to the destruction of the old canons of architecture that we should evaluate the various experiences

of architects and engineers, keeping in mind that even while we try to overcome the old dualism we should search for paths appropriate to new circumstances. The building-as-human-body analogy dating to Galileo was articulated at the beginning of the modern movement in two distinct ways. Freyssinet, mentioned above, can be seen as representing the point of view that form should express structure. The discoveries of the principle of shape resistance and of techniques of precompressed concrete allowed Freyssinet to consider construction as a unified thing, as would happen again in the automotive industry with the introduction of the self-supporting carriage. To this line of thought—inappropriately termed "organic"—is opposed another interpretation of building that tends to establish, using another naturalistic analogy (once again dating to Galileo), an essential division between skeleton and skin, between supporting and supported structure. Nineteenth-century architectural culture tended to side with this point of view, including such figures as Viollet-le-Duc and even more markedly Gottfried Semper and Auguste Perret.

It is in the footsteps of this tradition that, at the end of World War I, the young Le Corbusier illustrated the theory of autonomous structure of a building with his famous Maison Domino prototype. Perret's student would consequently develop an architectural theory—enunciating the "five points of a new architecture" (pilotis, free plan, free facade, roof garden, ribbon window)—that can be understood as an up-to-date version of the idea of a building divided into skeleton and skin.

It follows that Calatrava—and, it should be noted, the majority of twentieth-century formalist engineering as well—should be inserted into the tradition derived from Freyssinet—the French master, that "pure savage who walks instinctively"—even though he tends to develop themes by taking advantage of new developments in steel technology.

Here a first anomaly arises: since steel construction is composed of discrete elements, something also true of prefabricated concrete construction, we cannot rely on structural integrity.

This explains the attention paid to certain details of

organic skeletons, such as the thoracic cage or the dorsal spine, where continuity is obtained through a complex interrelationship of individual elements. Thus the possibility of joining the two models necessitates the adoption of complex geometries and structural models, approximating organic form so closely that the result generated is surprising or even excessive.

Up to this point everything we have mentioned would be traceable to twentieth-century structural research even if we note the presence of a new unsettling figurative tendency. But there is a point past which science, or Calatrava's art, ventures onto an even more precarious terrain. In his work one notes a type of problematization and the introduction of unknown elements that bring up the dialectic within scientific research and the vicissitudes of science in contemporary thought. In his memoirs we note a tendency to move from the direct representation of the world through explicit references to organs and natural phenomena to its explicit reproduction in a sort of magic simulation that goes beyond the traditional rational domain of analogy. In other words, the notebook introduces intimations and tensions we must approach with new arguments.

We can try to approach the question by noting how an admittedly idealized "classical" phase of science, characterized by greater certainties, a certain optimism, and shared models, was followed by another phase that we can call "romantic," characterized by divisions and diversions, a greater uneasiness, and a desire to break out of boundaries and conventions. This is the phase in which, in the words of Toynbee, an abyss opens between the "sensuality" of religion and the "asceticism" of philosophy.

I will take two emblematic figures to illustrate my argument regarding this separation. Observing how Peter Eisenman has developed Corbusian theories (only superficially hidden by his acknowledged affinity with Terragni's works), we can take him as the representative of "philosophical asceticism." The structural frame and the skin are interrogated by Eisenman's destabilizing fury to the point of paroxysm through an abstract game aimed at developing an autonomous and self-referential language, as

he himself has explained in great detail. The dizzy progression of his mathematical and geometrical paths, his declared antihumanism, the indefinite proliferation of forms made possible by the widespread adoption of computer design lead us to read a real and proper allegorical dimension (think of his imaginary archaeologies or of other inventions, or his adoption of principles the Möbius strip or DNA) in his architectural activity.

In allegory, in an "infinite network of meanings and correlations . . . everything can become a representation of everything else, but all within the limits of language and expression. To that extent it is possible to speak of allegorical immanence. That which is expressed by and in the allegorical sign is in the first instance something which has its own meaningful context, but by becoming allegorical this something loses its own meaning and becomes the vehicle of something else. Indeed the allegory arises, as it were, from the gap which at this point opens between the form and its meaning."[4]

If against our neo-romantic, fin-du-siècle background the theoretical neurosis of an Eisenman plays the role of the philosopher's allegorical understanding—conserving, at the same time, evidence of a personal style in times of eclecticism and hybridization—the figure of Calatrava comes to occupy the other position, that of the sensuality of religion.

If Eisenman tries to decipher reality allegorically, Calatrava's place is with the symbolic understanding of the mystics. It is well known that the essence of mysticism lies in a strongly symbolic expression of its own content and that by virtue of its iconic character it presents itself as a structure open to a broad understanding, whereas philosophy is forced to read architectural structure allegorically, depriving it for the most part of its specific import in order to bring it closer to truth and general formulas.

The concrete form of symbols necessarily becomes the result of an interaction with history: we can recognize a close bond between symbols and becoming. The concrete form of the symbols chosen by the "mystic" would thus be the result of the interaction between the tradition he looks to, his personal creative attitude, and the historical conditions in which he acts. We can include some of Calatrava's works in this definition by virtue of the difficulty encountered if one attempts to position them neutrally with respect to certain international trends based on general formal modules.

All of these are characteristics that distance Calatrava's work from the standardized formulas of high-tech movements against which, if for no other reason than contiguity, he will continually be destined to measure himself.

If we then attribute a gnostic pretension to mysticism, a certain religion that aspires to a direct and almost tangible experience of the divine presence, and we add the idea that "hard as the mystic may try to remain within the confines of his religion, he often consciously or unconsciously approaches, or even transgresses, its limits,"[5] we can include the kind of successes and obstacles that the world can reserve for the work of the exuberant Catalan planner.

1. Le Corbusier, *Towards a New Architecture*, trans. Frederick Etchells (New York: Dover Publications, 1986), 1.
2. Cited in Marie-Jean Dumont, "Il dominio del cemento armato," *Casabella*, June 1994, 47; originally published in *L'Architecture d'Aujourd'hui*, Feb. 1994.
3. Antoine Picon, "Santiago Calatrava: tettonica o architettura?" *Casabella*, Sept. 1994, 25.
4. Gershom G. Scholem, *Major Trends in Jewish Mysticism* (New York: Schocken Books, 1961), 26.
5. Scholem, *Major Trends in Jewish Mysticism*, 9.

Dedicated to Robertina Calatrava

Suvretta 1.1.95

The original dimensions of the notebook are 31.5 by 36.5
centimeters.

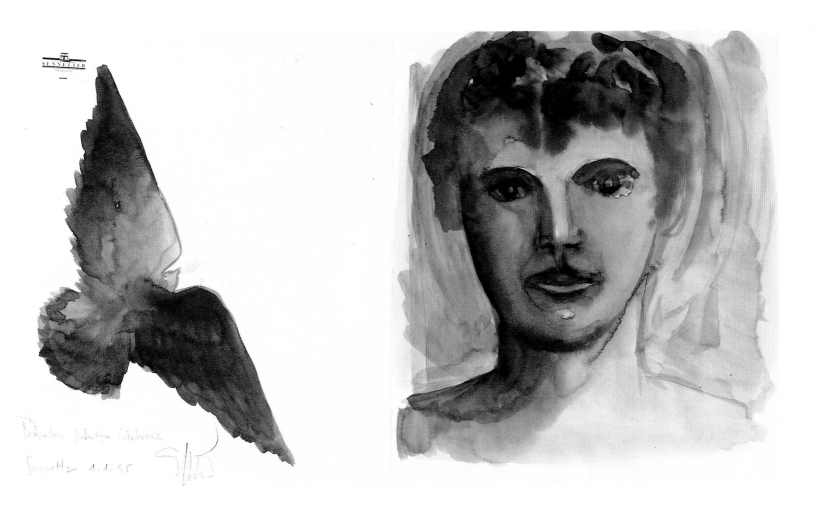

Redaction Robertson Cabotron2
Scharte 1.1.95

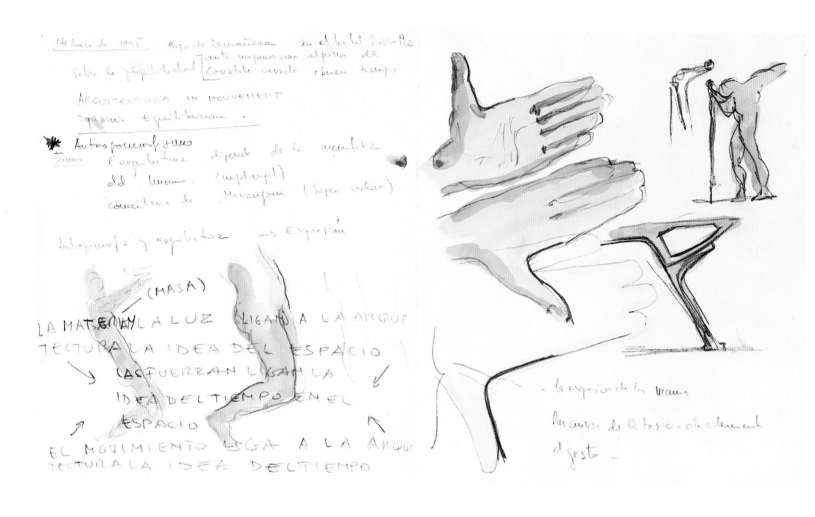

1 January 1995
 9:30 in the morning at the Suvretta Hotel
 in front of an alpine landscape of the
 snowy Corvatch, fair weather

on foldability
Architecture in movement
Dynamic Equilibrium

Anthropomorphism
Genesis architecture depends on the members of the
 human body.
 (Michelangelo)
 Marangoni's commentary (Knowing how to see)

Anthropomorphism and architecture → Expression
(mass)
mass and light bind the idea of space to architecture
 forces bind the idea of time in space
movement brings the idea of time to architecture

the expression of the hands
the curves of the transition between elements
the gesture

Stadelhofen Station, Zurich (pages 80–82)
The creation of a new track for the expansion of the Stadelhofen
station involved excavating the hill to create a new open tunnel.
The upper balcony is supported by inclined steel pilasters formed
of two cut sheets, each 110 millimeters thick, welded together;
the head of the pilaster is embedded in the three upper arms.

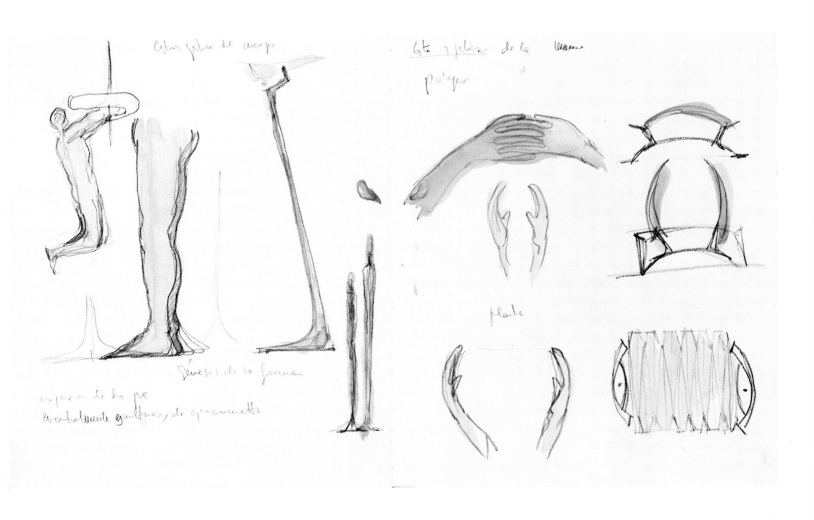

reading and gesture of the body
genesis of form

expression of the feet
eventually the sculptures of Giacometti

reading and gesture of the hand

to protect
plant

Kuwait Pavilion, Expo '92, Seville (pages 70–71)
The floor allows light to pass through. It is built of semi-transparent marble sheets glued to stratified glass. This rests on a structure of beams made of wooden studs.
The roof, which can be opened, is made of tubular wooden beams with a triangular section. Every element is moved by a different motor, which allows the structure to take on continually changing shapes. The supporting structure of the roof is made of prefabricated reinforced concrete pilasters. Every pilaster is made up of two pieces, glued together with special resins.

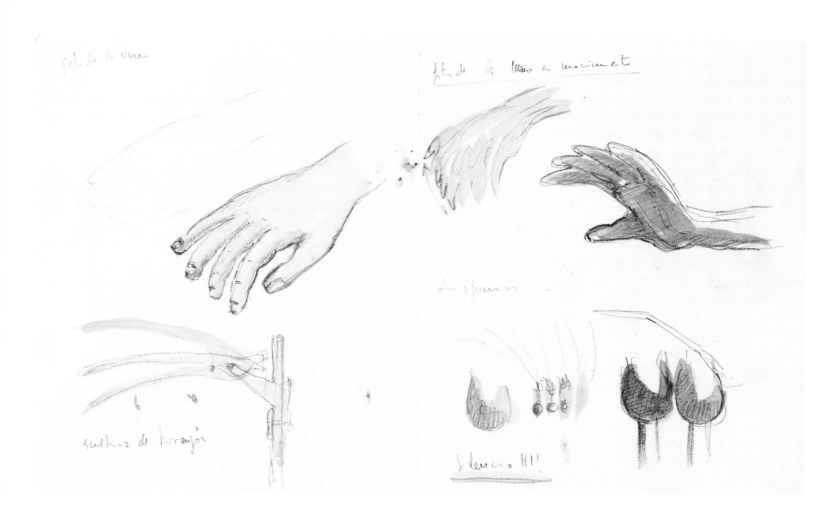

hand gesture

sculpture in concrete

photo of the hand in movement

other influences

silence!!!!

Mobile Elements (pages 60–61)
The mobile sculptures, one for the Swissbau '89 Pavilion and one for the Museum of Modern Art in New York, are constructed in concrete. All the beams are moved by a single motor; the transmission mechanism allows the movement of each element to be staggered.

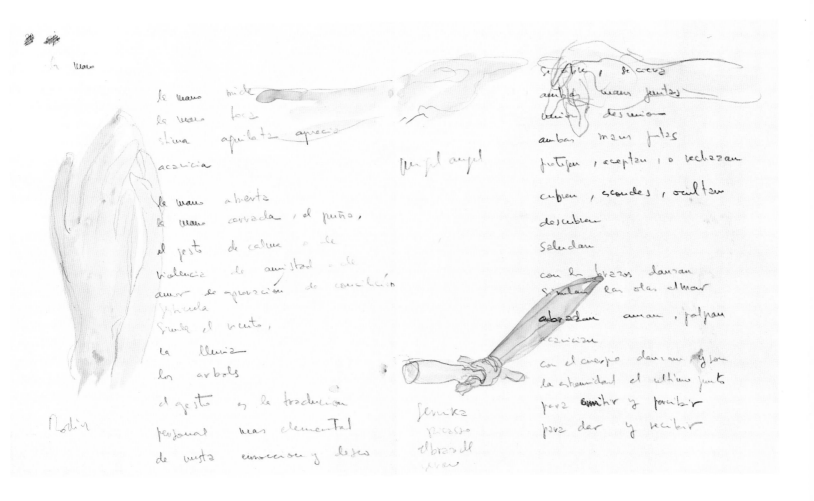

the hand

 the hand measures
 the hand touches
 values examines appraises
 caresses

 the open hand
 the closed hand, the fist,
 a gesture of calm or of
 violence of friendship or of
 love of approval of reconciliation
 it gestures
 mimics the wind,
 the rain, the trees
 the gesture is the most elemental
Rodin personal translation
 of our emotion
 and of our desire

Michelangelo

it opens, it closes
the two joined hands
union of unions
the two joined hands
protect, accept, or push away
cover, hide, conceal
discover
greet
dance with the arms
mimic the waves of the sea
adore love, feel
caress
dance with the body and are
the extremities the last point
for emitting and perceiving
for giving and receiving

Guernica
Picasso
the arm of
the warrior

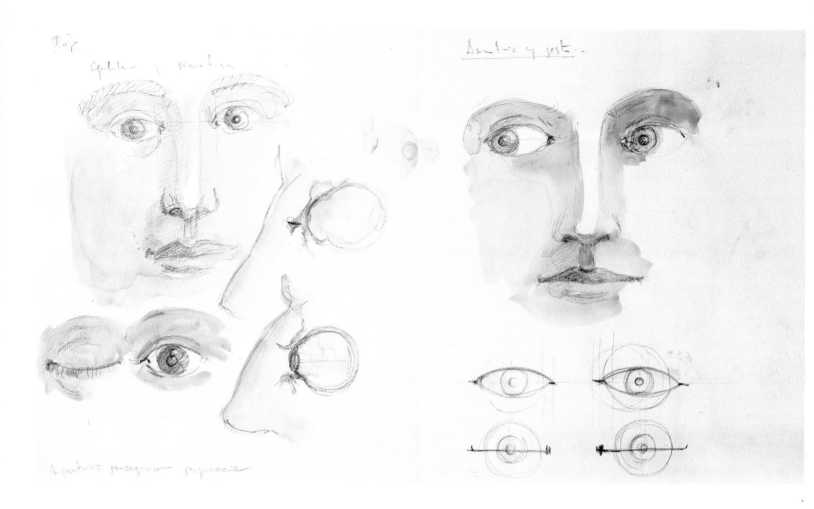

the eye

Equilibrium and symmetry

Opening perception perspicuity

Asymmetry and gesture

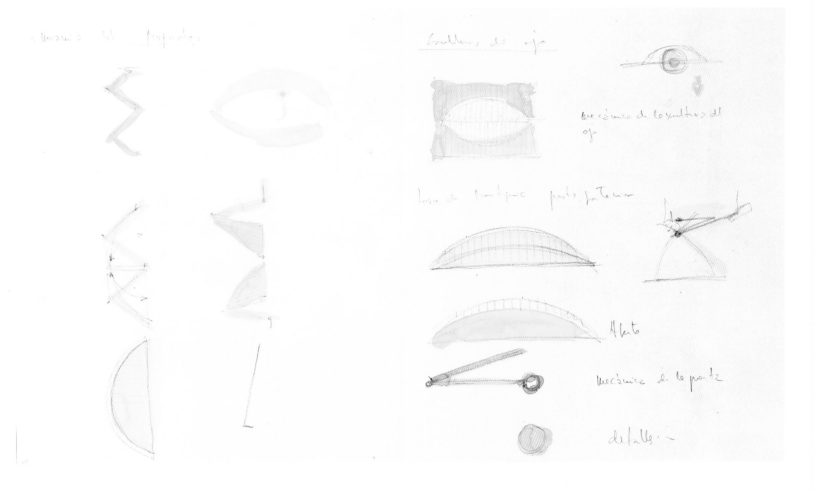

the mechanics of the eyelid

Telecommunications Tower, Montjuic, Barcelona (page 64)
The 136-meter-high steel tower rests on three points on a
reinforced concrete base clad with artificial stone. The part
housing a water basin is clad in ceramic.
The tower houses the telecommunications system used for
the Olympics.
The base is reached by an arch of about 30 meters, closed by
a door of metal sheets activated by a single hydraulic motor.
The movement (an arch that rotates 90°) refers to the studies
of eyelid movement, already experimented with in some mobile
sculptures.

Eye sculpture

mechanics of the eye sculpture

Montjuic tower rear door

Open
mechanics of the door
details

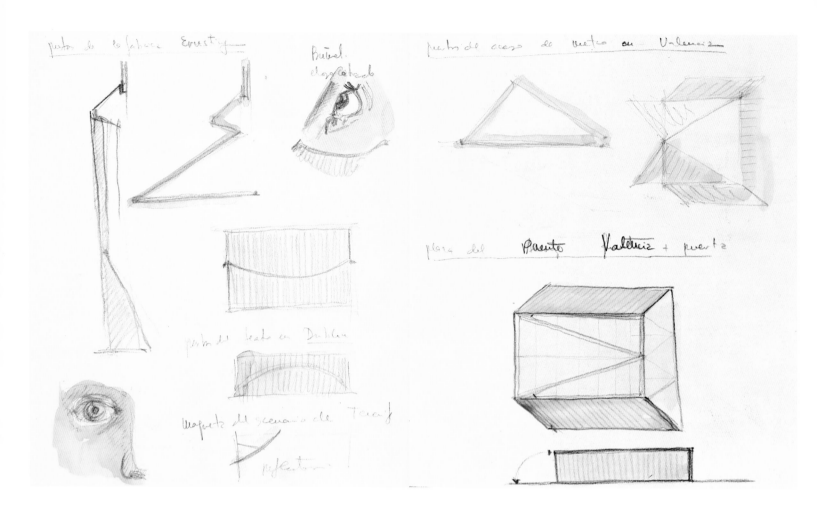

doors for the Ernsting factory

Buñuel
the cut eye

door of the theater in Dublin
model of the theater stage
acoustic reflector

entrance doors of the Valencia metro

plaza under the Valencia bridge + door

Ernsting Factory, Coesfeld (pages 62–63)
The opening of the doors is determined by the movement of
a horizontal beam in the form of an arch that is as long as one
vertical floor. The thin metal plates of different lengths form
a concave arch.
The same idea is expressed in the project for the backdrop of
the Dublin auditorium. Here, however, the thin metal plates are
cut to form a convex arch.

Alameda Bridge and Station, Valencia (page 88)
The station is entered from the covered plaza created by the
new bridge. The entrance door is made of a plane that slides along
an inclined axis; when it is closed it becomes part of the paving of
the plaza.

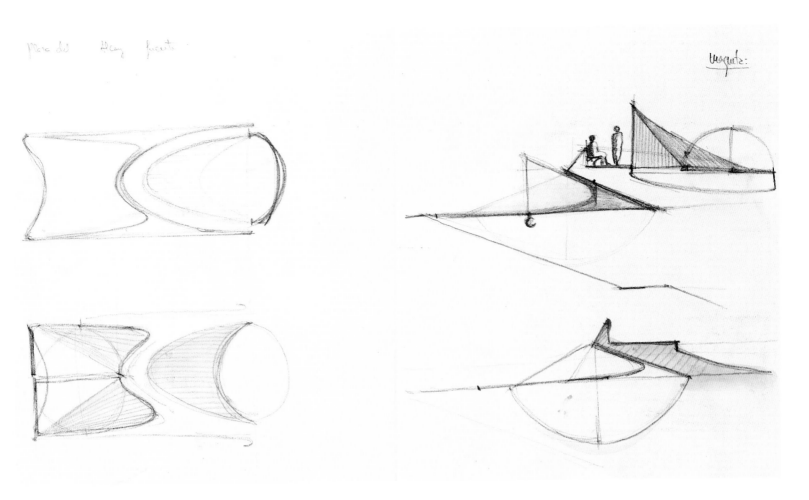

Alcoy plaza *fountain* <u>model</u>

Plaza and Fountain, Alcoy (pages 66–67)
The plaza in front of the city hall was dug out to make room for a
large, underground public assembly room, accessible by two doors
on opposite sides.
Over one door is a basin of water covered by a grill made of
stainless steel tubes with a square section that are cut to different
lengths and form an arch. A motor allows the tubes to move and
the grill to open.

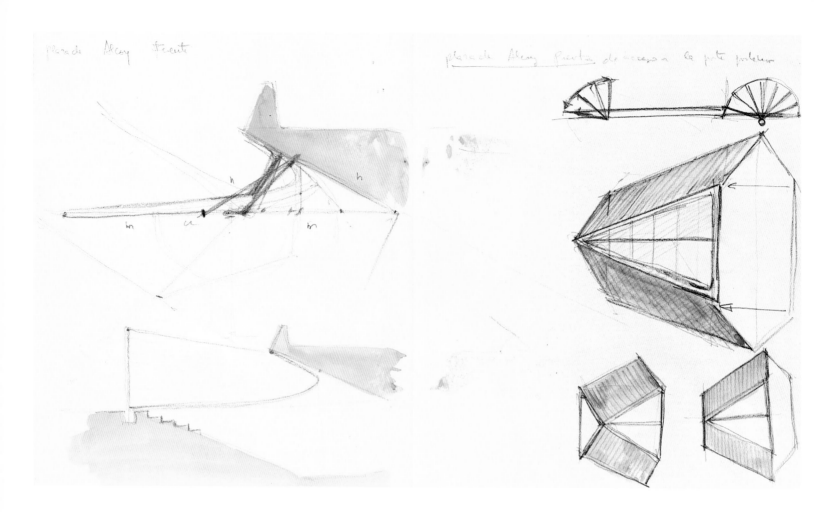

Alcoy plaza *fountain*

<u>*Alcoy plaza*</u> *entrance door to the rear part*

Plaza and Fountain, Alcoy (pages 66–67)
The entrance doors to the underground room open in two different
ways: one is a hinged door, the other a triangular plane that slides
upward.

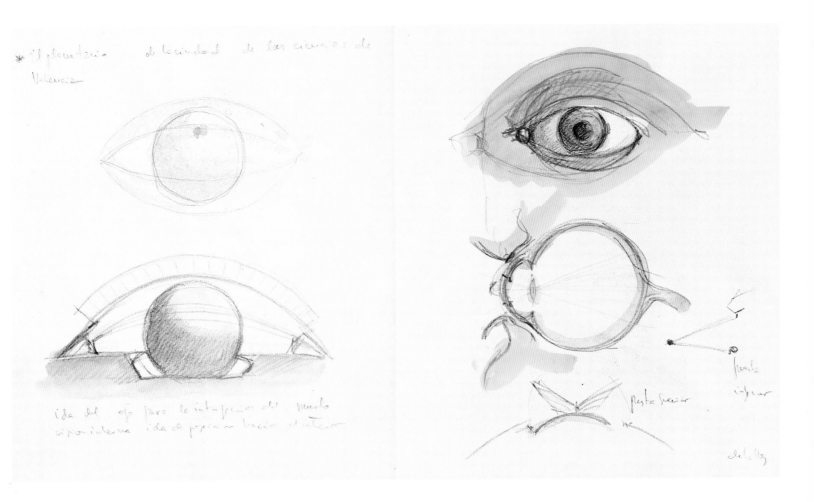

The planetarium of Valencia's city of science

*the idea of the eye for the introspection of the world
interior vision idea of perception from inside*

Planetarium, Valencia (page 73)
The hemispherical planetarium is enclosed in a reinforced concrete
structure which can be opened at the top and the bottom. Two
oblique surrounding arches support a reinforced concrete shell and
the skylight. The three elements that open are built of a mobile
metal structure to which are affixed sheets of stratified glass.

*lower door
upper door
details*

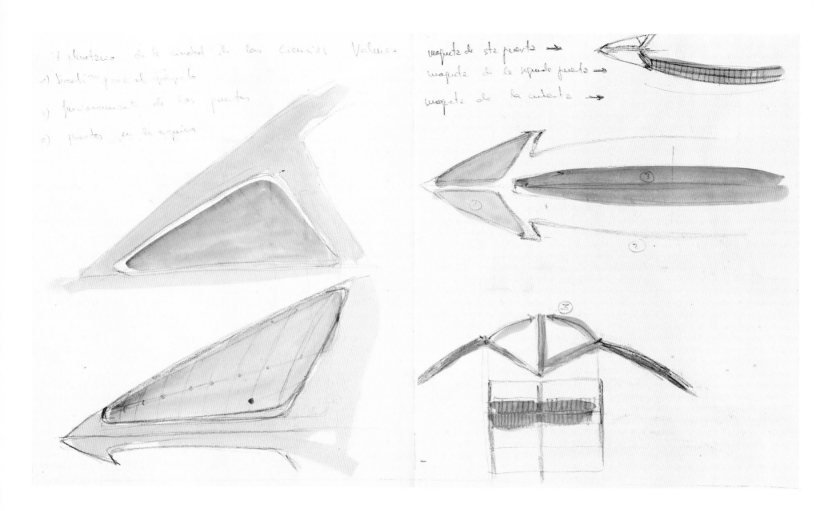

The planetarium of the city of science Valencia
1) sketches for the project
2) mechanism of the doors
3) doors at the corner

model of this door →
model of the second door →
model of the roof →

Planetarium, Valencia (page 73)
The entrance doors to the planetarium are on the two
opposite sides.
A structure and a metal net form a triangular plane that
turns around an eccentric vertical axis.

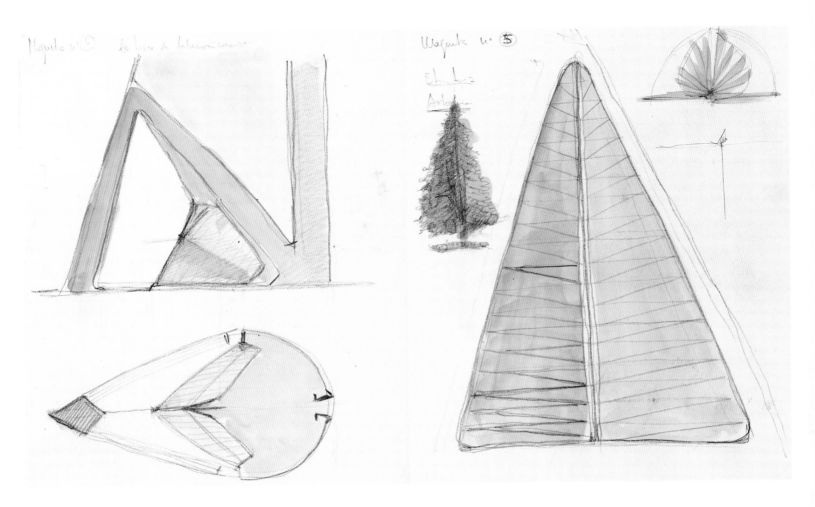

model no. 4 *the telecommunications tower*

Telecommunications Tower, Valencia (page 74)
The reinforced concrete tower stands 386 meters high and houses offices on the lower level, which are separated from the telecommunications tower itself by a few floors reserved for public uses. The metal entrance doors are made of a triangular surface that rotates around an inclined axis.

model no. 5

Structure
Arboreal

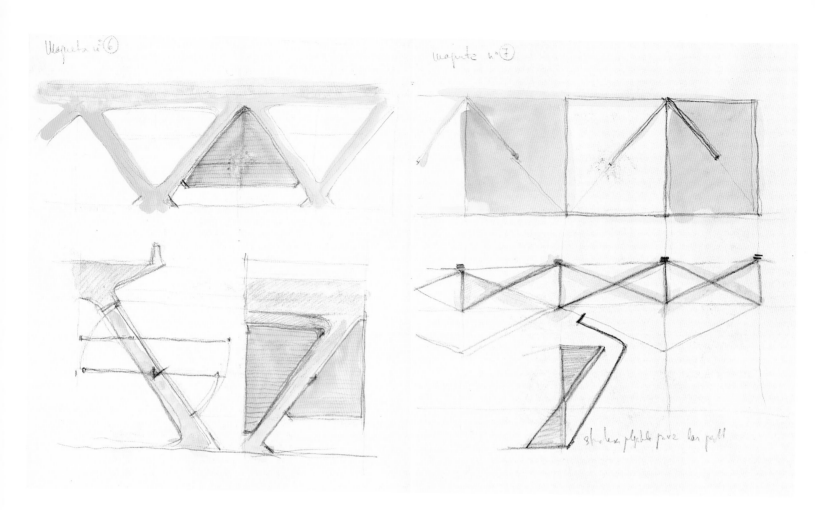

model no. 6

model no. 7

foldable structure of the doors

Science Museum, Valencia (page 72)
The reinforced concrete structure is closed by a system of triangular
doors that rotate around a horizontal axis.

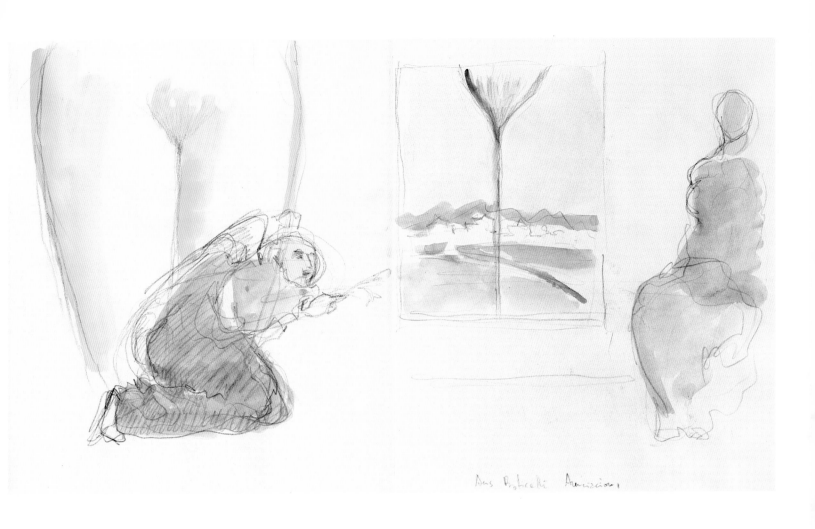

Botticelli's Annunciation

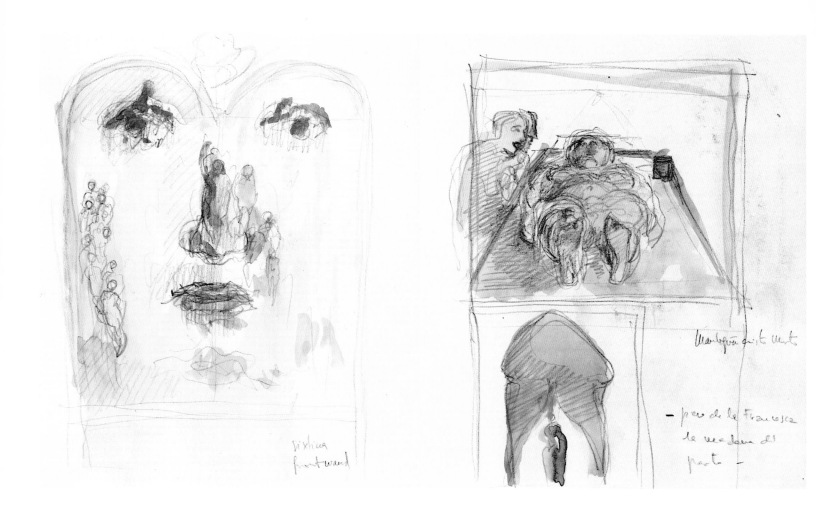

*Sistine
front wall*

Mantegna Dead Christ

*Piero della Francesca
the Madonna del Parto*

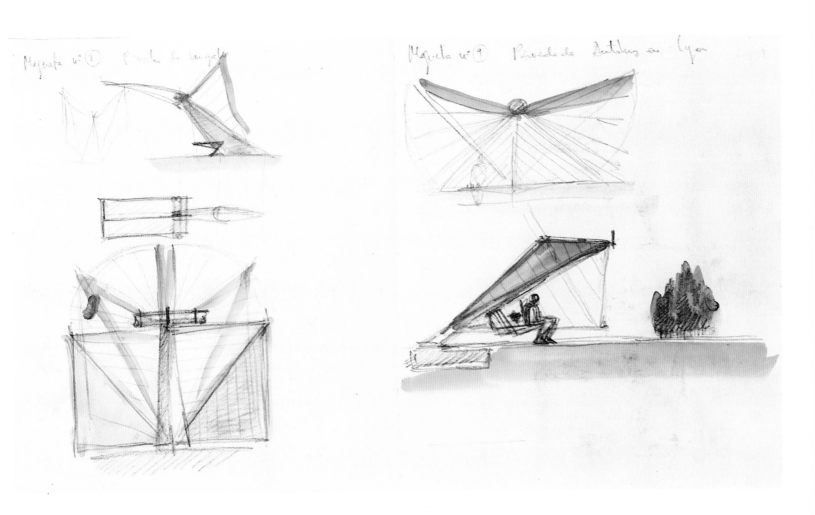

model no. 8 *San Gallo Station* model no. 9 *Bus shelter in Lyon*

Shelter, San Gallo (page 65)
The shelter is made of a fixed structure of metal and glass, held up
by a longitudinal tube, and of a lateral mobile structure also made
of metal and glass in the shape of two wings, each formed of two
folded planes which open by means of a motor.
The same mechanism is planned for the bus shelter in Lyon. In this
case, however, the parts that open are single rigid planes.

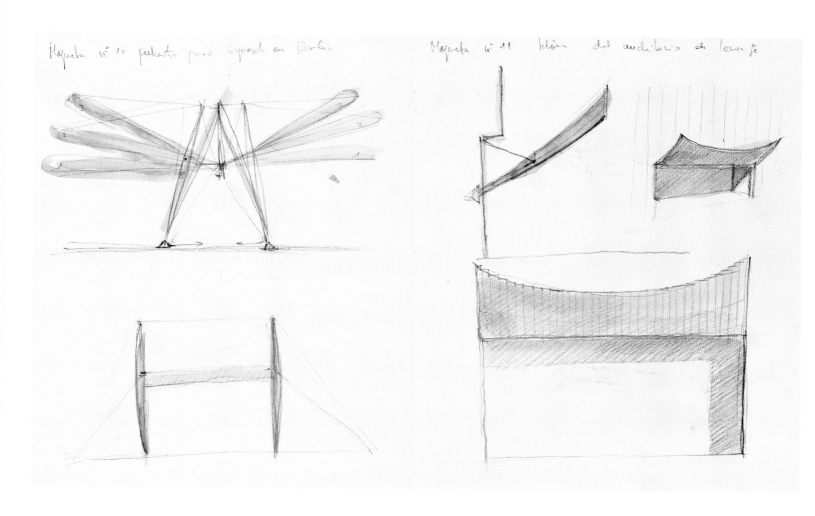

model no. 10 *squash courts in Berlin*

model no. 11 *drop curtain for the Tenerife auditorium*

Sports Pavilion, Berlin (page 61)
The mobile roof covers two open-air squash courts which are placed inside a courtyard. The covering, which is stable in any given position, is made of a wooden structure covered in copper.
The movement is achieved with a single motor whose power is transmitted through a system of cables.

Auditorium, Santa Cruz de Tenerife (page 75)
The main auditorium for 2,000 spectators allows for a maximum distance between the orchestra and the audience of 17 meters. By rotating the platform the orchestra can be positioned at the center of the auditorium.

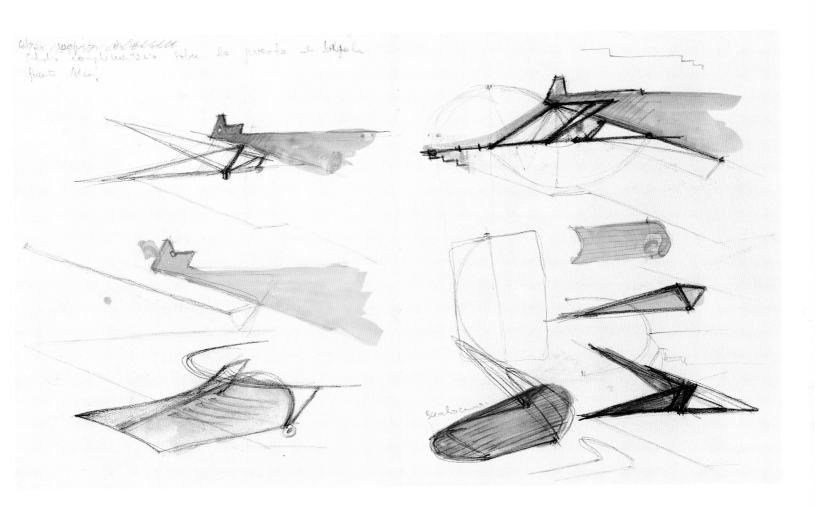

supplementary study for the door
and the fountain of Alcoy

Plaza, Alcoy (pages 66–67)
The entrance door under the fountain.

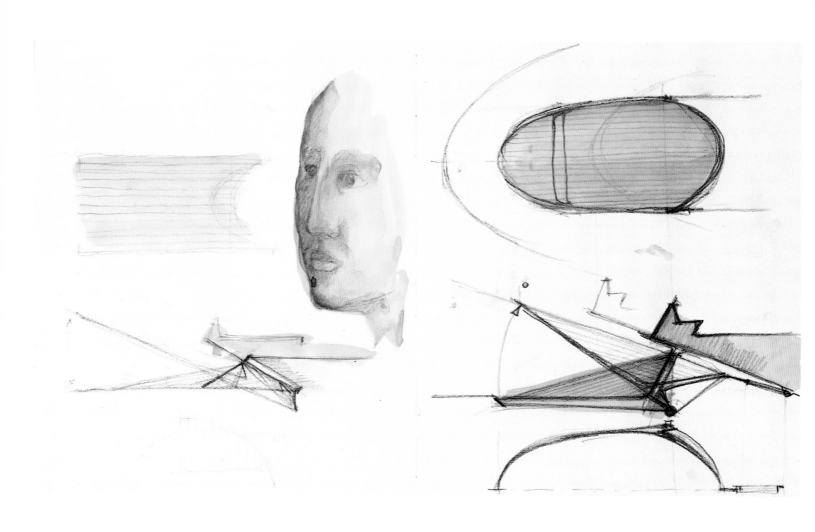

Plaza, Alcoy (pages 66–67)
The entrance door under the fountain.

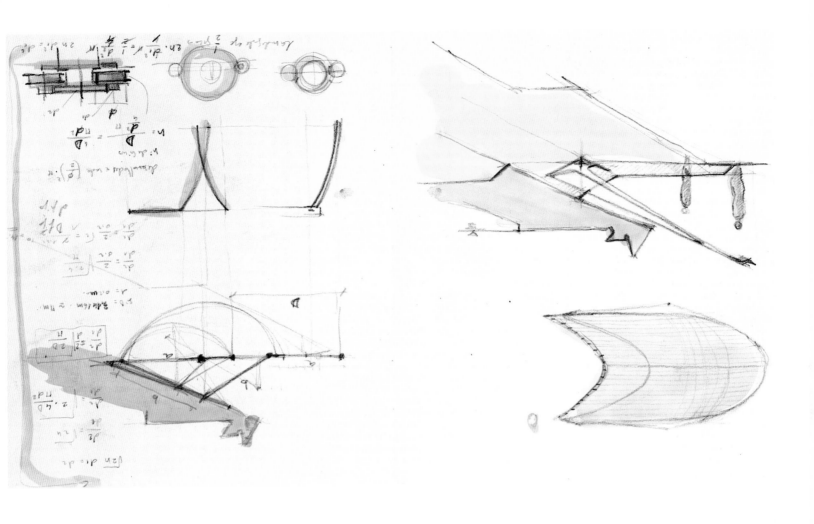

31

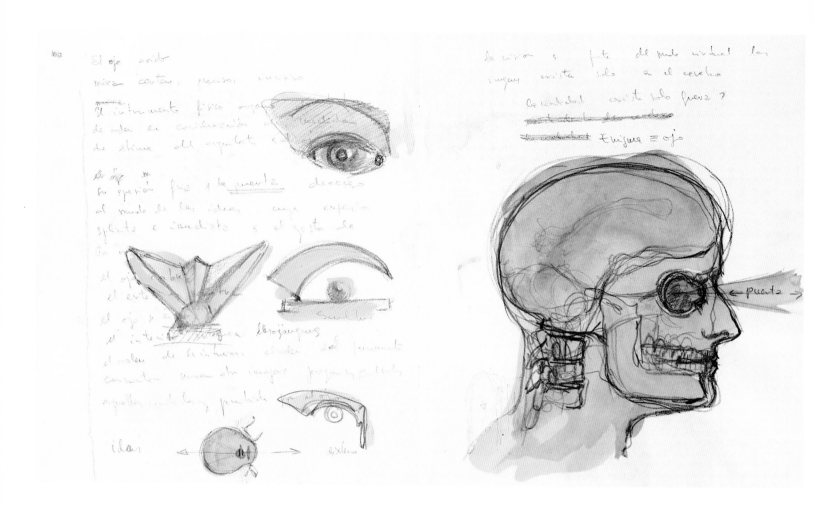

The avid eye
looks confidently, precisely, incisively
the physical instrument organ
of order of consideration of measurement
of admiration of the architect is the eye
its cold expression is the entrance door
to the world of ideas whose
explicit and immediate expression is the gesture
of the hand
the eye opens
the outside penetrates sculpture
the eye closes
in the inside images are generated
the order of intuition, the order of
conscious thought re-creates other images, they judge and control
those received and perceived by the eye

ideas ← → exterior

vision is the door of the virtual world the
images exist only in the brain
reality exists only outside?

Enigma/eye

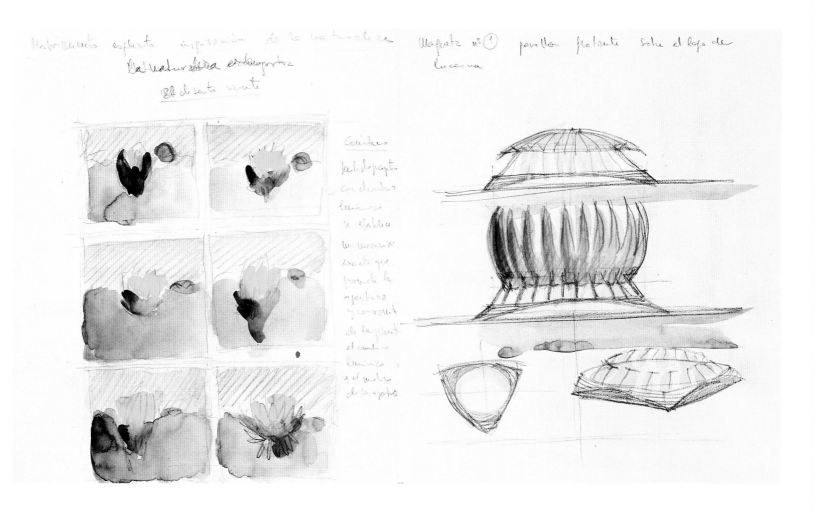

Explicit movement inspiration from nature
<u>*the living desert*</u>

<u>*comment*</u>
perceptive sense
with the changing light an exact mechanism is established
that permits the plant to open and close
the changing light is the reason for the transformation

model no. 1 floating pavilion on Lake Lucerne

Floating Pavilion, Lake Lucerne (page 68)
Planned for the seven-hundredth-anniversary celebrations of the Helvetic Confederation, the pavilion rests on a floating platform about thirty meters in diameter. It is made of a reinforced concrete deck, waterproof and divided into compartments, which will be anchored at various points of the lake.
The roof can be opened and is made of independent sheets, each one moved by its own motor, and fixed to an inclined supporting pylon. All the elements are of reinforced concrete.

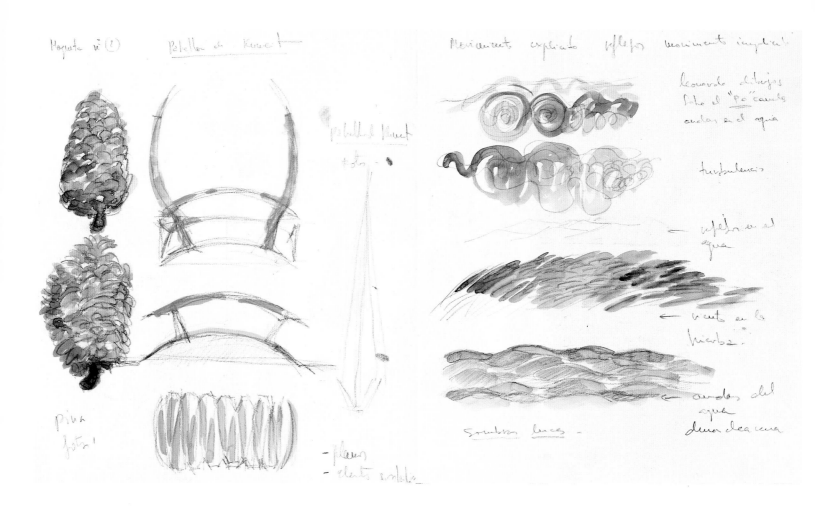

model no. 2 *pavilion in Kuwait*

 pavilion in Kuwait
 photo

pine cone plants
photo construction elements

Kuwait Pavilion, Expo '92, Seville (pages 70–71)

Explicit movement	*reflections*	*implicit movement*
		Leonardo sketches
		on the "Po" canals
		waves in the water
		turbulence
		reflections in the water
		wind in the grass
shadows lights		*waves of the water*
		sand dunes

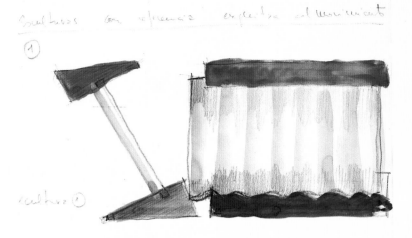

Sculturas con referencia explícita al movimiento

① sculture ①

$$CO\ MENTARIO: \quad f = m \times a$$

LA FUERZA = MASA POR ACELERACIÓN

ACELERACIÓN \Rightarrow NOCIÓN DE TIEMPO EN

UN RECORRIDO

$$a = \frac{d^2 e}{dt^2} = |\bar{a}| = \frac{|\bar{e}|}{|\bar{t}|}$$

LA LUZ Y LA MATERIA (MASA) DEFINEN EL ESPACIO

LAS FUERZAS LIGAN A LA ARQUITECTURA

LA COMPONENTE CINEMÁTICA DE LA ACELERACIÓN

(SON) MOVIMIENTOS POTENCIALES

(IMPLICAN)

SON MOVIMIENTOS CRISTALIZADOS

EL MOVIMIENTO LIGA A LA ARQUITECTURA LA

IDEA DEL TIEMPO

EL TIEMPO ES UNA NOCIÓN EXISTENCIAL ELE

MENTAL IMPLICA EL SENTIDO DEL CAMBIO

QUE CONDUCE AL PASO AL UNIVERSO DE

LAS IDEA

MUERTE

luz (materia) idea

tiempo

sculptures with an explicit reference to movement

sculpture 1

explanation: static change of light → sensitivity
of the object to the movement of the observer.
static change of light → sensitivity
of the object to the movement of time, i.e. of the sun
of the daylight reflections environmental changes
are gathered by the object and perceived by the observer

comment: f = m x a
force = mass times acceleration
acceleration ⇒ idea of time in a direction

the light and the material (mass) define the space
the forces lead to architecture
the cinematographic component of acceleration
(are) (involving) potential movements
are crystallized movements
movement leads to architecture
the idea of time
time is an elemental existential notion
involving a sense of change
that leads to the progress of ideas
to the universe
light (material) death idea

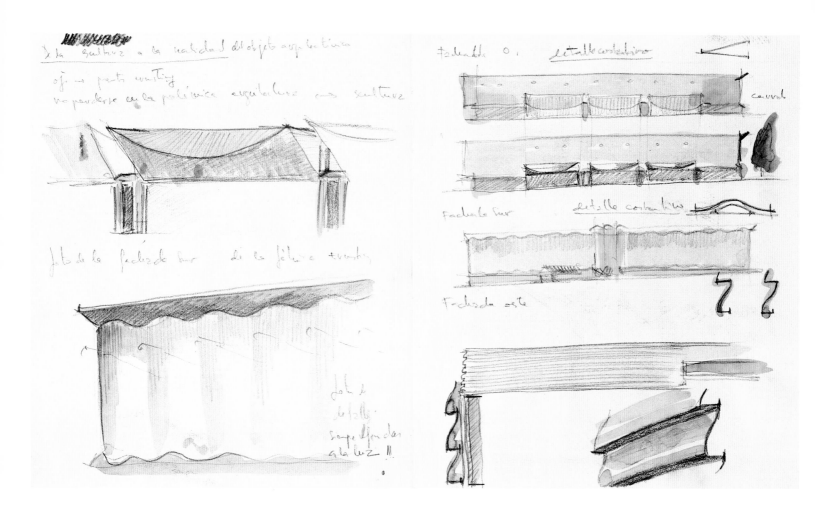

From sculpture to reality of the architectural object
eye → Ernsting door
not to lose oneself in architectural polemics ↔ sculpture

photo of the south facade of the Ernsting factory

photo of the
details
always with reference
to the light!

west facade *construction detail*

 closed

south facade *construction detail*

east facade

Ernsting Factory, Coesfeld (pages 62–63)
The four facades of the existing industrial building were
transformed with different kinds of aluminum cladding used in
different ways: flat sheets, ribbed siding set vertically and buckled
to form curves, ribbed siding set on a flat surface.

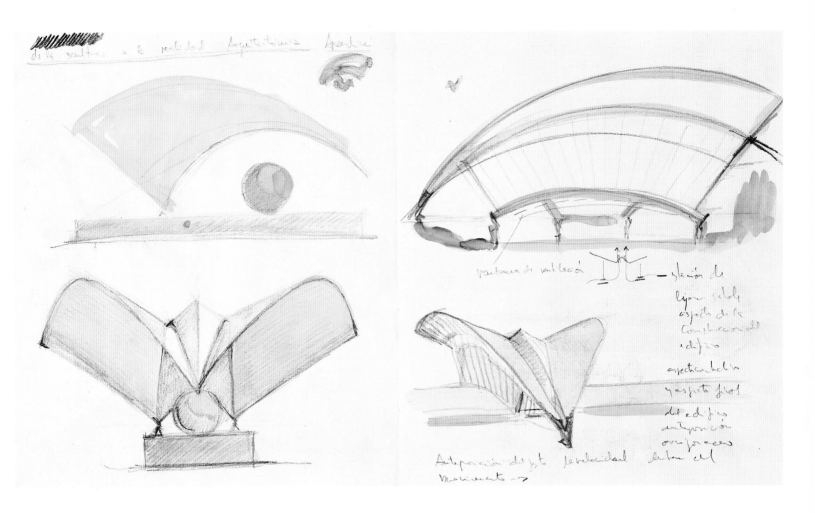

Satolas Station, Lyon (pages 76–79)
The station is constructed out of two elements: the tunnel for the
trains, built in reinforced concrete, and the large access and
distribution hall resting on top of it, built with a metallic structure.

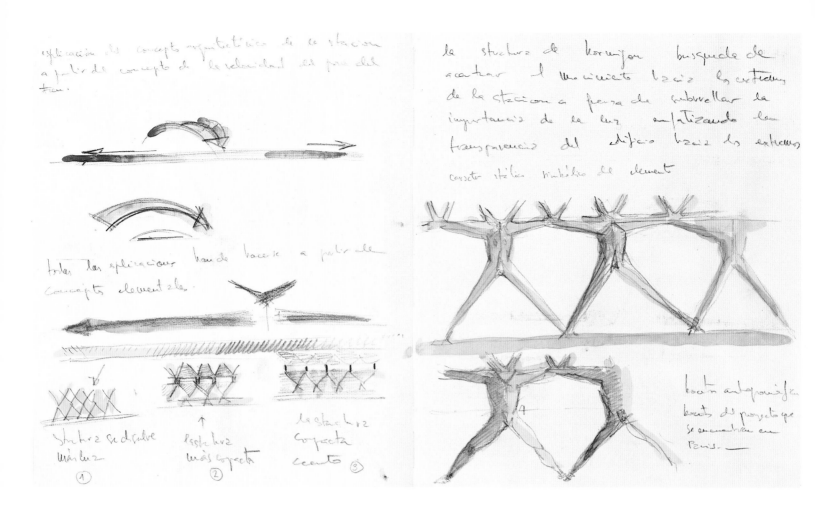

explanation of the architectonic concept of the station
beginning with the concept of the velocity of the train's movement

all explanations must begin with elemental concepts

The structure dissolves more light	The structure more compact	The structure compact center
1	2	3

the cement structure attempt to
accentuate the movement toward the ends
of the station insisting on underlining
the importance of the light emphasizing
the transparency of the building toward its extremities

static symbolic character of an element

anthropomorphic sketches
sketches of the project that
are in
Paris

Satolas Station, Lyon (pages 76–79)
The train tunnel is made up of a series of modular elements in
reinforced concrete, cast on site with steel forms. The basic module
is nine meters long and refers to the length of one car of the train.
The structure becomes more and more open as it nears the exterior.

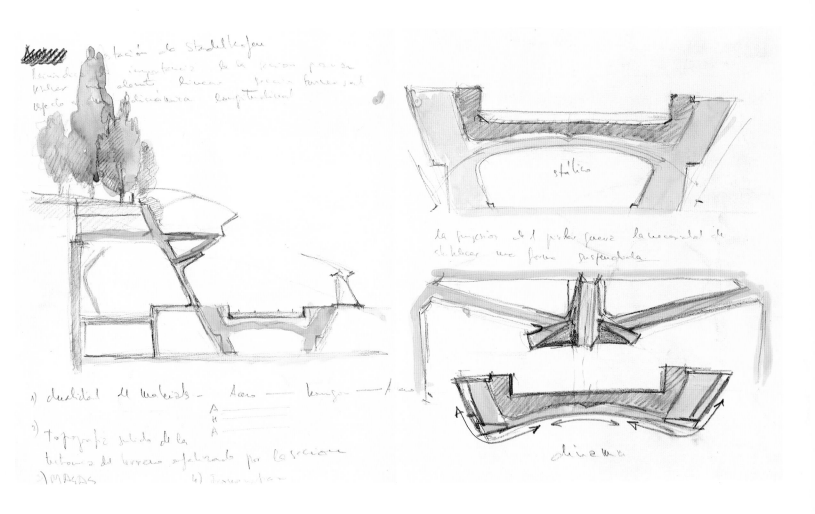

Stadelhofen station
proves the importance of the section to resolve an element
linear section with respect to a longitudinal dynamic

1) duality of materials steel-concrete
 A
 H
 A
2) topography sense of the
 tectonics of the terrain emphasized by the section
3) masses
4) iconography

static

the suppression of the pilaster generates the necessity of creating a suspended form

dynamic

Stadelhofen Station, Zurich (pages 80–82)
The underground tunnel, which houses a commercial center, is actually a long viaduct on which two central tracks run.
At the points of entry the supporting pilaster has been suppressed.
In this case the arch rests on a suspended joint, fixed with cables precompressed to the structure.

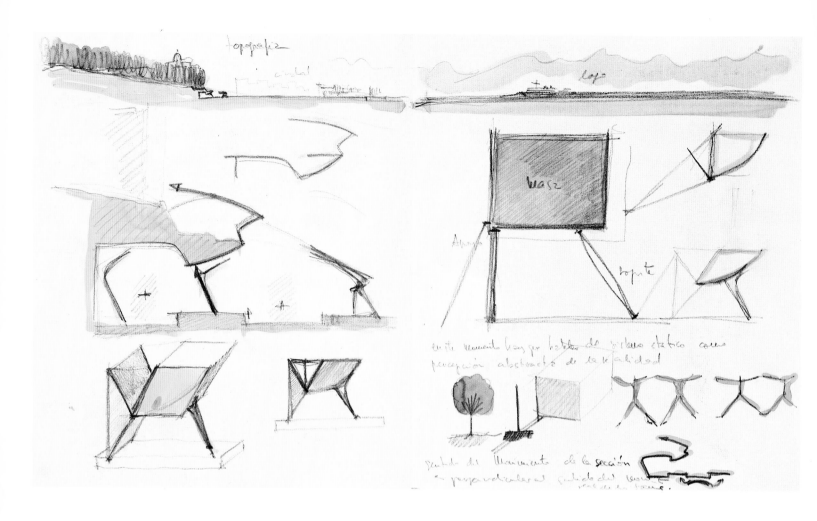

topography
city

lake
mass
rest support

Stadelhofen Station, Zurich (pages 80–82)
The project was defined in reference to the orthography of the terrain: the cut in the hill opens toward the lake.
The balconies of reinforced concrete rest on the steel structure of the pilasters.

here we must talk of the static system as abstract perception of reality

sense of movement of the section perpendicular to the real sense of movement of the trains

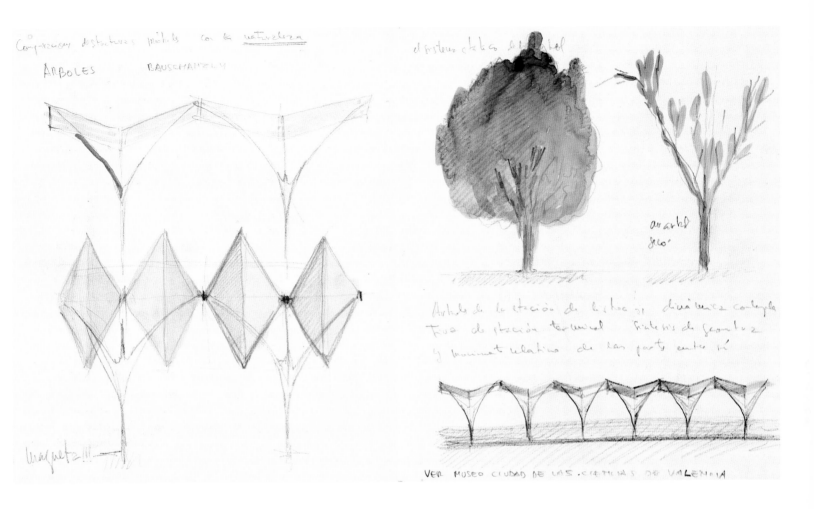

Comparison of mobile structures with <u>nature</u>
Trees Bauschänzly

model!!!

Pavilion on an Island, Zurich (page 69)
The restaurant, on a wooded island in the middle of the lake,
is roofed with a structure of twelve-meter-tall metal trees; each
one can be opened with an independent motor.

static system of the tree

a tree
dry

Trees of the Lisbon station, contemplative dynamic
of terminal synthesis of geometry
and relative movement of the parts among themselves

the museum Valencia city of science

Science Museum, Valencia (page 72)

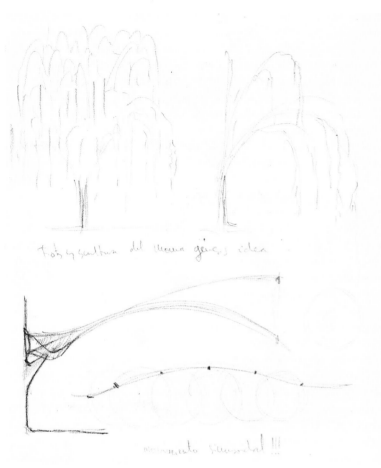

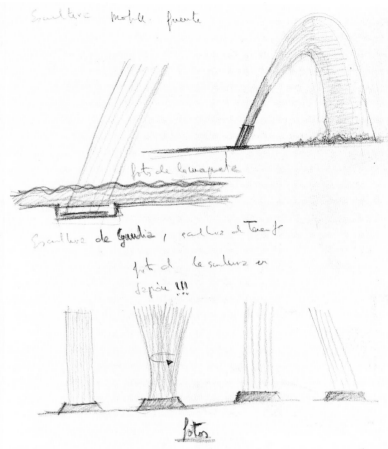

photo and sculpture of MoMA *genesis of the idea*

sinusoidal movement!!!

Sculpture, Museum of Modern Art, New York (page 60)

mobile fountain sculpture

photo of the model

sculpture for Candia, sculpture for Tenerife
 photo of the sculpture in
 Japan!!!

photo

Project for a Mobile Fountain (page 93)
The movement of the thirty-meter-high metal poles, which spurt
jets of water, is guided by a single motor.

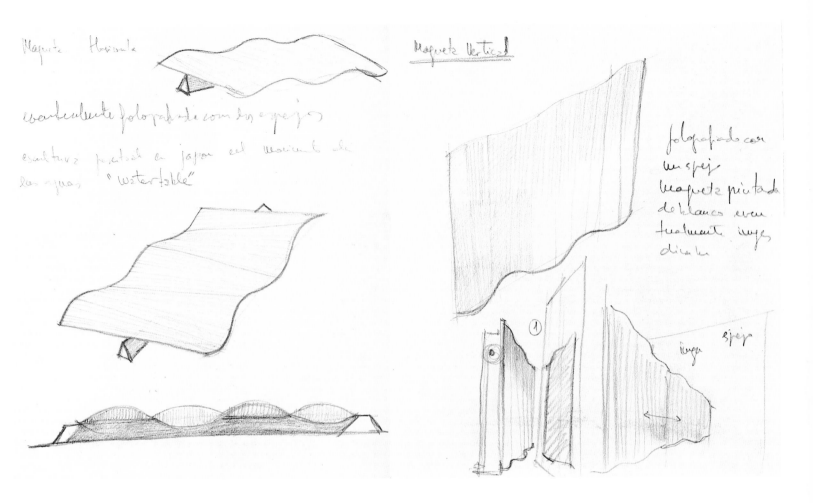

horizontal model

eventually photographed with mirrors

sculpture presented in Japan the movement of the waters "watertable"

vertical model

*photographed with
a mirror
model painted white
eventually dynamic
images*

images mirror

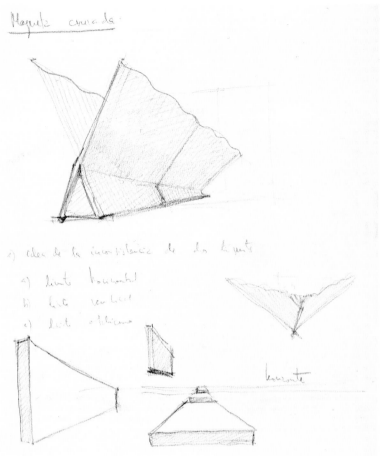

Maqueta cruzada:

Elements implicits de dinámica.
1) la dinámica en los estados de equilibrio

1) idea de la inconsistencia de los limits

a) limit horizontal
b) limit vertical
c) limit oblicuo

horizonte

intersecting model

1) idea of the inconsistency of limits
a) horizontal limit
b) vertical limit
c) oblique limit

horizon

implicit elements of dynamics
dynamics in states of equilibrium

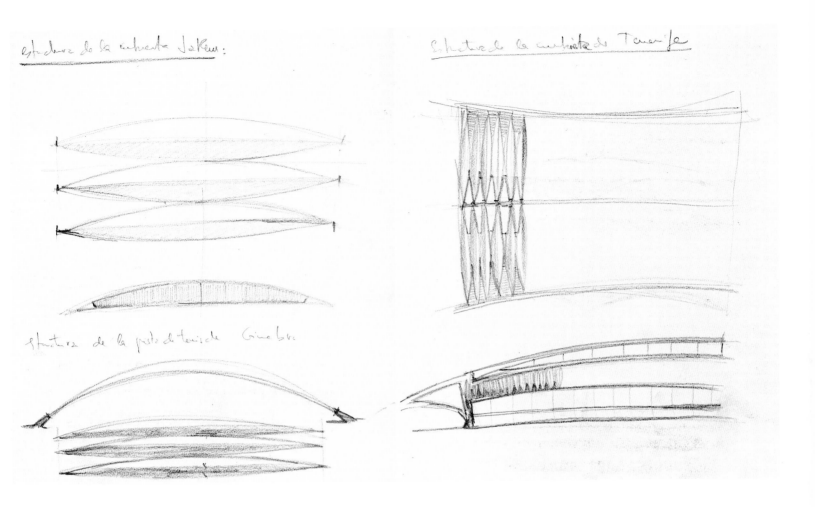

structure of the Jakem roof

Structure of the Tenerife roof

structure of the Geneva tennis court

Roofs (pages 84–87)
The roofs of the exhibition building of Tenerife, the Jakem Factory,
and the Geneva Sports Center are designed with a steel parabolic
shape that permits light to penetrate from above.

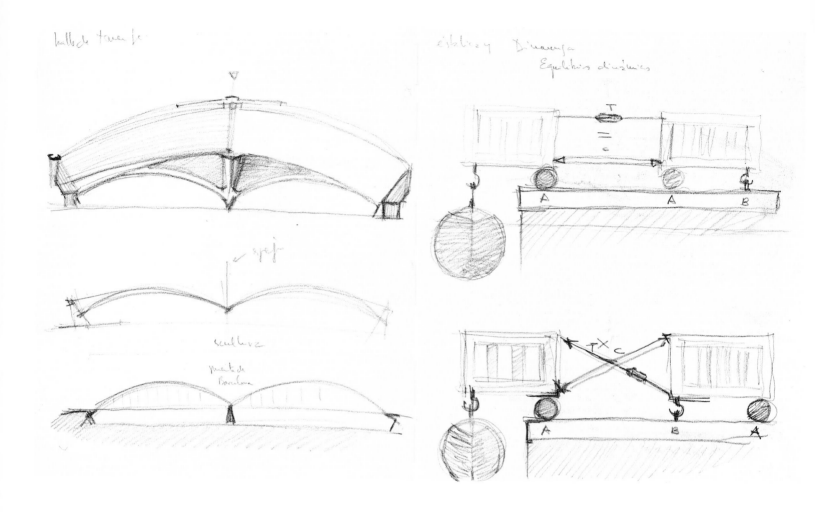

hall in Tenerife

> *mirror*
> *sculpture*
> *Barcelona bridge*

Statics and Dynamics
> *Dynamic equilibriums*

Gran Via Bridge, Barcelona (page 90)
Two arches rest on a single point in the middle of the river. The two
arches have a triangular plan, thus reducing the cable system.

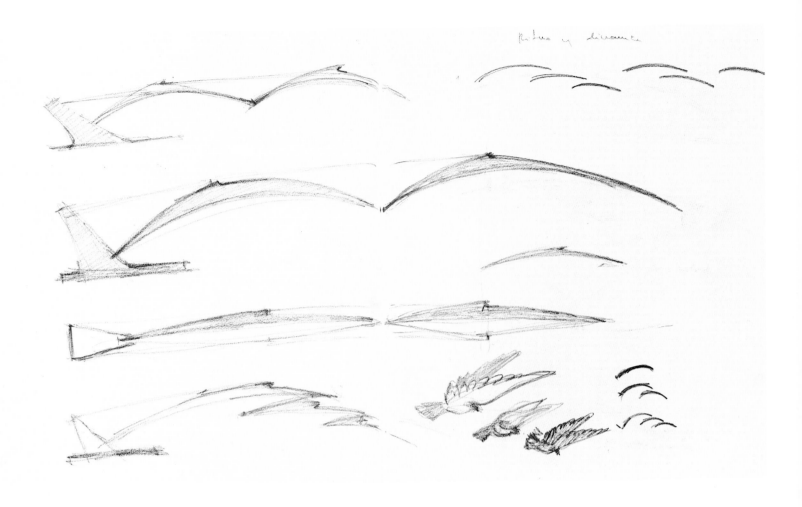

Rhythm and dynamics

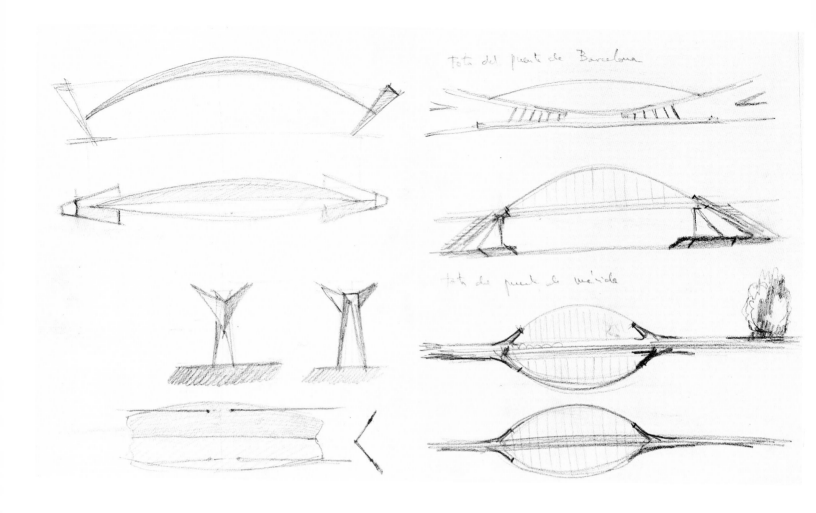

Photo of the Barcelona bridge

photo of the Merida bridge

Bach de Roda Bridge, Barcelona (page 90)
The bridge is made up of two principal arches, each one inclined
and integrated with a secondary arch. The steel structure allows for
automobile traffic in the center and pedestrian traffic on the two
exterior balconies.

Lusitania Bridge, Merida (page 92)
A single metal arch on axis with the bridge rests on two reinforced
concrete elements placed forty-five meters apart.

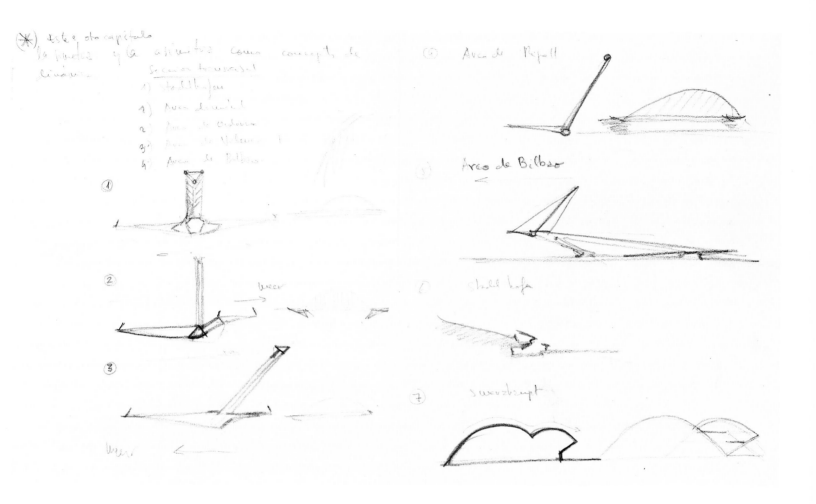

Bridges (pages 88–92)
The Lusitania Bridge in Merida is based on a symmetrical vertical arch.
The Ria Bridge in Ondarroa, on an asymmetrical vertical arch.
The Alameda Bridge in Valencia, on an asymmetrical tilted arch.
The La Devesa Bridge in Ripoll, on an asymmetrical tilted arch.
The Campo Volantin Bridge in Bilbao, on an inclined arch with a curved plan.

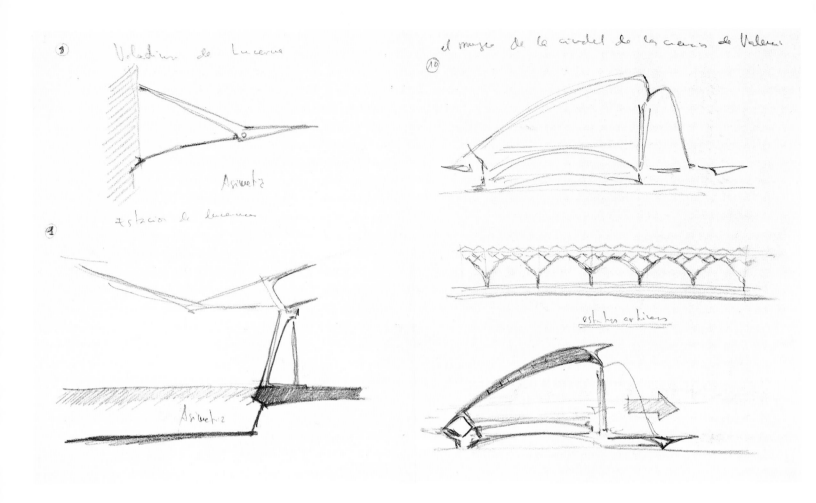

Lucerne Shelter

> asymmetry

Lucerne Station

> asymmetry

Post Office, Lucerne (page 83)
The metal shelter, extending 11.25 meters, is attached to the building's structure. The various flat elements, placed according to the resulting curve of loads and forces, are stiffened by an anterior member resembling the wing of an airplane.

Station, Lucerne (page 83)
The glass roof (108 by 19 meters) of the large entrance atrium of the station is suspended by steel cables from the building and from the new portico (built with prefabricated reinforced concrete elements).

The museum of Valencia's city of science

> *tree-like structures*

Science Museum, Valencia (page 72)
An arcuated structure of reinforced concrete holds up the metal structure of the glazed wall and the roof.

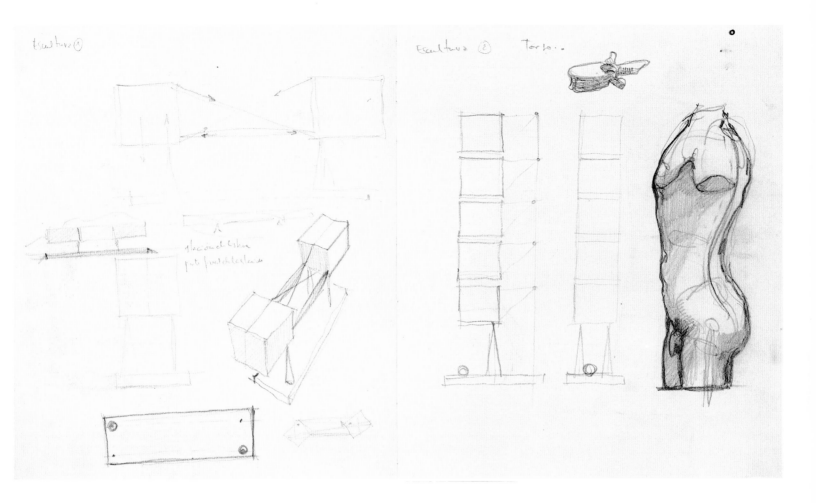

sculpture 1

 Lisbon station
 final door of the station

sculpture 2

 torso

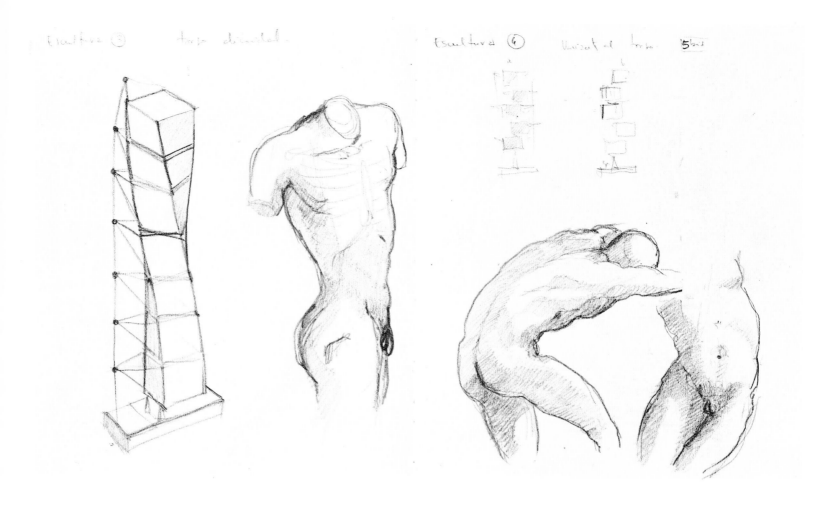

sculpture 3
 helicoidal torso

sculpture 4
 variations on the torso *5 bis*

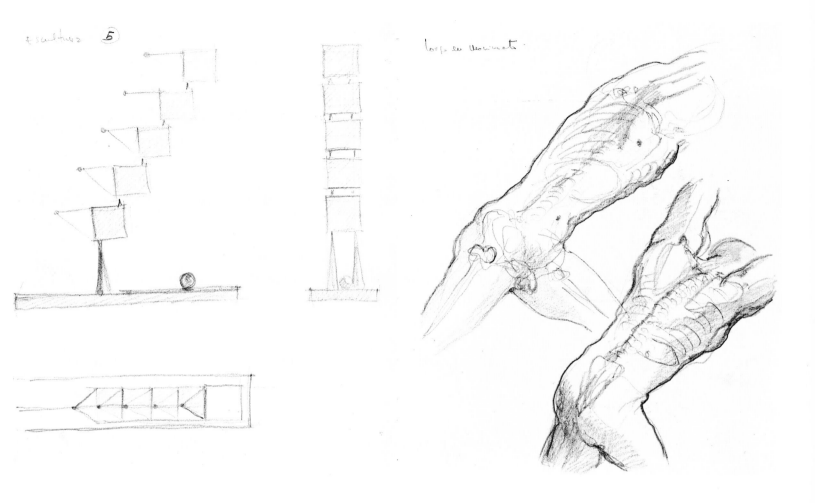

sculpture 5

torso in movement

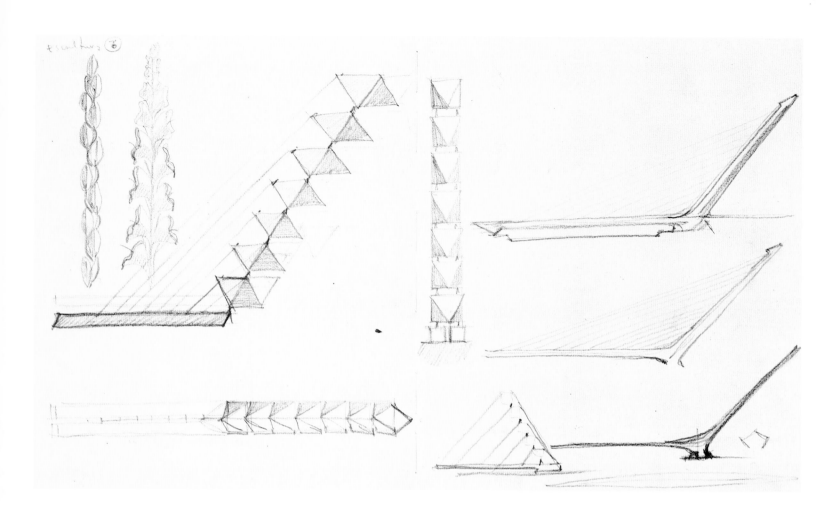

sculpture 6

Alamillo Bridge, Seville (page 92)
The 250-meter-long bridge is held up with 13 cables affixed to a
142-meter-high pylon, which is inclined at an angle of 58 degrees.
The weight of the pylon is sufficient to counterbalance the bridge.

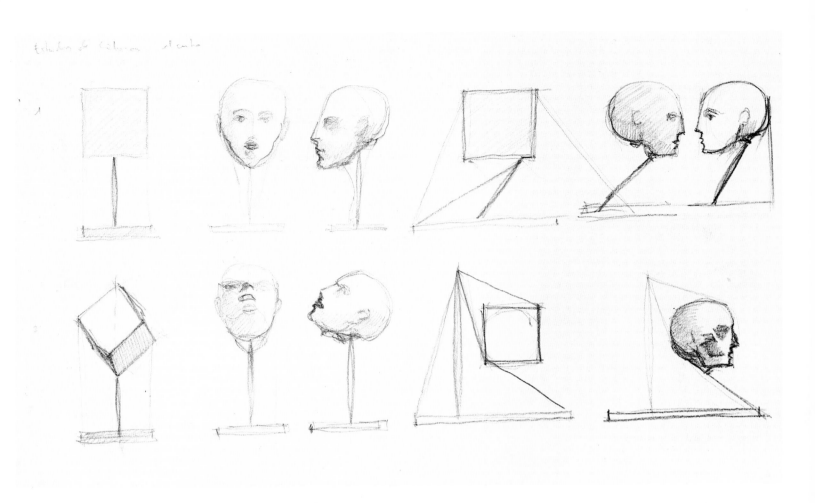

studies of heads *the cube*

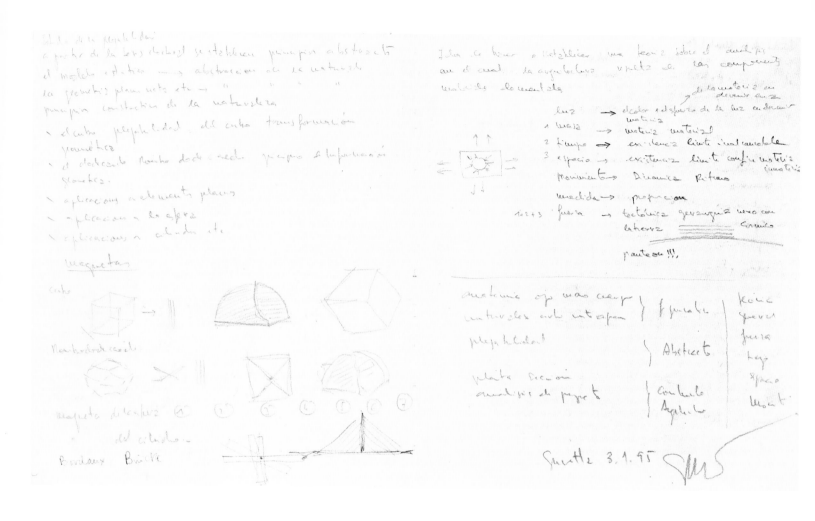

study of foldability
beginning with the doctoral thesis abstract principles are
established
the static model → abstraction of nature
geometry, plane, straight line, etc. → abstraction of nature
construction principles of nature
—the cube foldability of the cube transformation
 geometrical
—the dodecahedron, rhomboidal dodecahedron principle of
 geometrical transformation
—application in planar elements
—application to the sphere
—application to cylinders, etc.

models
cube

rhomboidal dodecahedron

model of the sphere 1 2 3 4 5 6
model of the cylinder
Bordeaux Bridge

idea of making or reestablishing a theory of analysis
in which architecture results from elementary material components

light	→	the color is the force of the material in becoming light of the light in becoming material	
1 mass	→	material matter	
2 time	→	existence unreachable limit	
3 space	→	existence confined limit innate material	
movement	→	Dynamic Rhythm	
measure	→	proportion	
1+2+3 force	→	tectonic hierarchy link with the earth	cosmic
		Pantheon!!!	

anatomy eye hand body

nature tree metaphor	figurative	abstract
		general
		force
foldability	abstract	time
plan section		space
analysis of the project	context	
	architectonic	movement

Suvretta 3.1.95

56

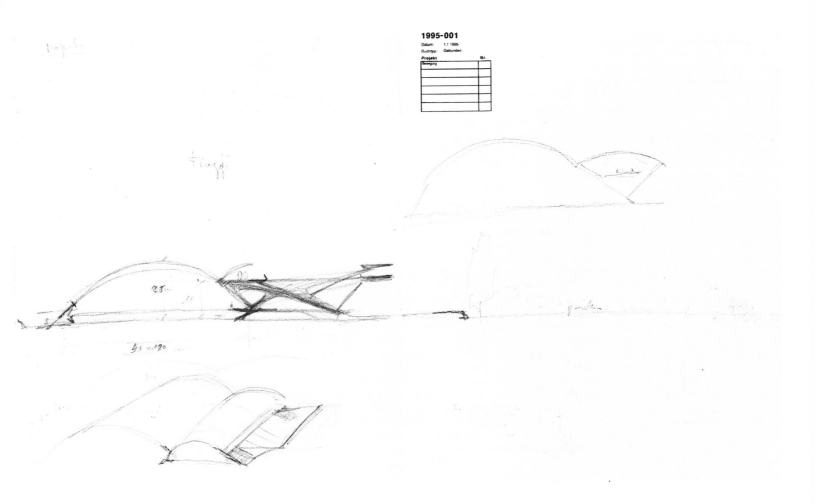

1995-001
Datum: 1.1 1995
Buchtyp: Gebunden

Projekt	Nr.
Bewegung	

models

Fiuggi

Mobile Pages *Mirko Zardini*

Many of Santiago Calatrava's buildings and constructions can be understood as moving objects. Through the movement of a few elements, their configuration can change over time. Even when this does not happen, however, their forms still suggest a dynamic equilibrium of forces, a movement frozen at a given time. But in contrast to many other buildings and infrastructures, they cannot be seen as easily relocated objects; in the end they are immobile.

Immobile Constructions

Santiago Calatrava's constructions root themselves in the ground. At times, as in the Stadelhofen Station in Zurich, the project's intention is precisely that: to modify the terrain. Here the existing hill is cut by a new tunnel and then extended and remodeled with a balcony and four bridges that arch over the tracks. At the foot of the hill, under the tracks, the terrain is cut again by a second tunnel—a commercial street—which is then roofed by the level of the tracks. This viaduct thus reestablishes the continuity of the terrain by means of a new ground plane. The tunnels, balconies, and shelters create an artificial hill facing the lake. Likewise, in Lyon's Satolas Station, the large hall rests on an artificial ground plane: the train tunnel itself, which is cut into the earth and from which, at a distance, emerges the single covering structure. The mobile fountain in the new plaza at Alcoy—at times a level ground, at others a sculpture—reveals itself to be another artificial ground plane; it in fact serves as the roof of the new communal hall carved into the ground underneath. For the telecommunications tower at Montjuic in Barcelona, Calatrava makes use of a circular base partly occupied by a basin of water; the large exhibition hall in Tenerife rests on an artificial ground level that takes advantage of the irregular shape of the terrain.

Even the "mobile" pavilions of Zurich and Seville or the Valencia planetarium find a base ready to support them, whether in the form of a bastion in the river as in Zurich, or

a plinth as in Valencia, or a covered plaza as in the pavilion for Expo '92 in Seville. The bridges, too, tend to be anchored in a precise place, with a system of ramps as in Ripoll, or with a base as in Merida or Seville. More than technical elements used to direct traffic, the bridges are conceived of yet again as extensions of the surrounding terrain. At times they are rest areas—actual plazas—as in the Bach de Roda Bridge in Barcelona; at others, such as in the Alameda in Valencia, the bridge becomes a roof for the plaza underneath, thus determining the position of the station along the railroad tracks.

Crystallized Movements

Calatrava's geographic or geologic vocation thus tends to fix—at times even to root—his constructions in a place, making them immobile. At the same time, the constructions themselves seem to dematerialize. The more the base of the building is emphasized, made heavier, or embedded into the earth, the more the rest of the building becomes light, mobile.

To explain his work, Calatrava has often referred to the idea of dynamic equilibriums or of frozen motion. The laws of statics are only one instance of dynamic laws. In this book as well, Calatrava refers to a formula, $F = m \times a$, force equals mass times acceleration. Thus the static solution of a building is only a moment of equilibrium in the complex play of forces, a moment that becomes represented and highlighted through crystallized movements.

In his structural solutions Calatrava plays with decomposing forces into their component elements. In this way, as Alejandro Zaera has observed, instead of concentrating the mass of the structure in the supports, following the law of gravity, Calatrava moves the mass to another point, resolving the structural problem through the decomposition of the forces into their discrete elements: compression, deflection, torsion. Naturally, the hinges are the focus of attention: the joints, the connections. And to highlight this decomposition, the result of different structural needs, Calatrava turns to different materials at different times: cement—whether precompressed or not—stone, wood, steel, glass.

Mobile Buildings

Very often Calatrava's constructions do not merely present crystallized movements but are actually mobile structures. The building is no longer a fixed element, but one that assumes different configurations, changing over time with respect to the various needs and uses of its spaces. It is enough for Calatrava to play with standard elements such as doors and windows to change the appearance or shape of the entire building. The doors of the Ernsting Factory, when open, transform the flat surface of the metal facade into a play of light and shadow. The door of Montjuic, when open, reveals a long cut in the earth: the entrance to a cave. The doors of the Stadelhofen Station seem like huge skylights which can be opened, roofs that raise themselves up to draw us in. Part of the pavement of the Alcoy Plaza rises up suddenly to become a sculpture revealing the mirrored plane of water below.

At other times it is the roof, the covering, that opens and closes, to protect, or to follow the play of light, as in the dome for the Berlin Reichstag competition project, the Valencia planetarium, the shelters for San Gallo and Lyon, and the sports pavilion in Berlin. In some cases—the Expo pavilion for Seville and the floating pavilion on Lake Lucerne—the building is reduced to a moving covering, semitransparent, a membrane that wraps around us.

The references to the natural world—to trees, flowers, or skeletons of animals—are thus not simply the result of formal analogies. In the world of natural forms, movement, whether slow or fast, is the rule. It is a world of unstable equilibriums, always changeable, in which the bodies or the plants assume ever-changing shapes.

Natural Landscapes

Calatrava thus seems to put the idea of a building itself into question. What remains of the traditional idea of a train station in the case of Stadelhofen? How can we define the Alameda intervention in Valencia—as a bridge, a plaza, or a station? How can we define the building in Alcoy? Maybe we can call the projects pavilions, artificial terrains, shelters, but not stations, restaurants, museums, planetariums; their destined purposes do not coincide with their configurations.

Perhaps, rather than thinking of them as buildings, they should be considered fragments of a new landscape, transformations of the terrain upon which the roofs or coverings rest.

They are not, however, examples of ephemeral architecture, meant to last thirty years, as foreseen by modernist rhetoric. To the contrary, these buildings champion stability; their bases root themselves into the ground. Instead of thinking of time only as a problem related to their lifespan, these constructions incorporate it within themselves. They are already predisposed to vary over time, to assume different configurations. For this they can be defined as natural constructions.

Mobile Elements Sculpture, Museum of Modern Art, New York, 1993 (pages 14, 42)

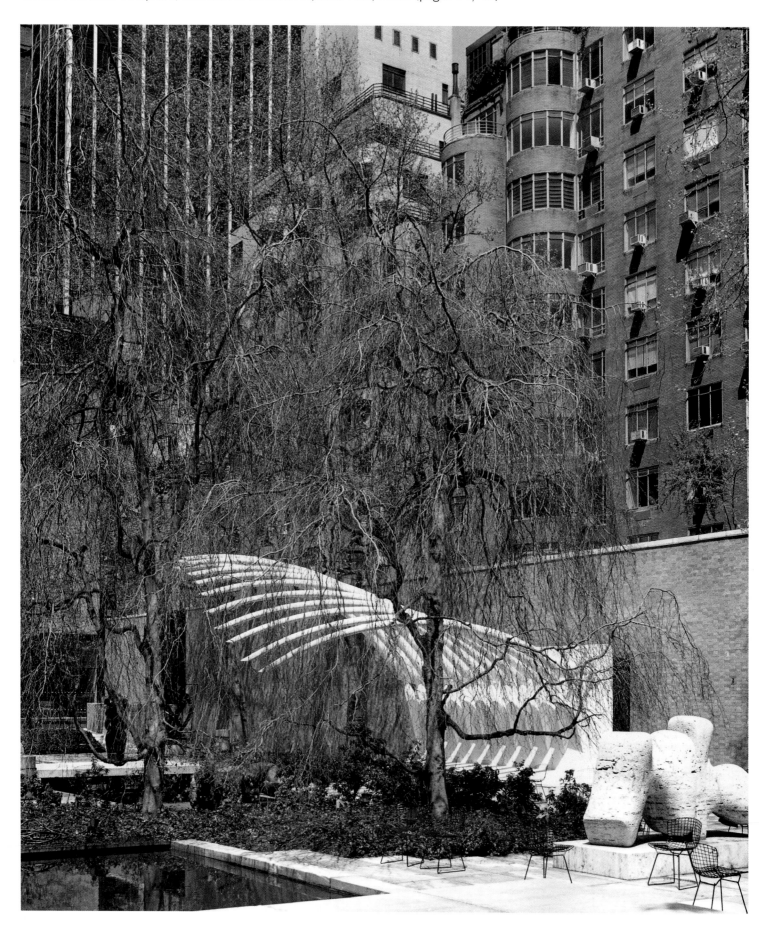

Pavilion, Swissbau '89, Basel, 1989 (page 14)
Sports Pavilion, Berlin, 1980 (page 28)

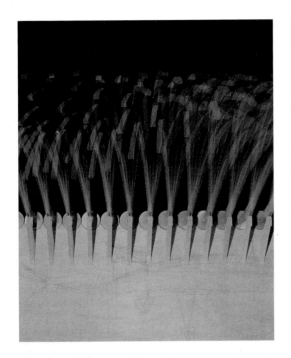
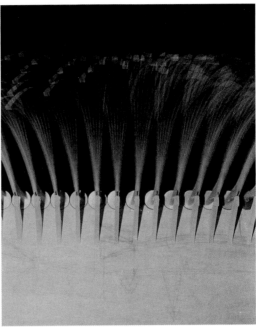

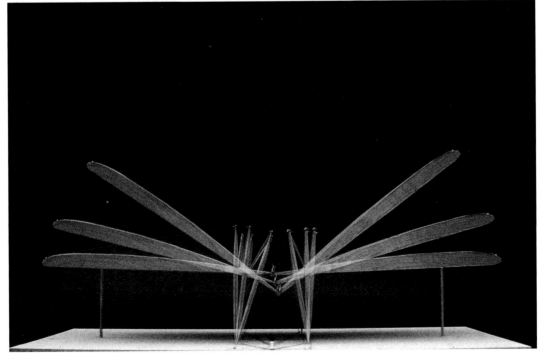

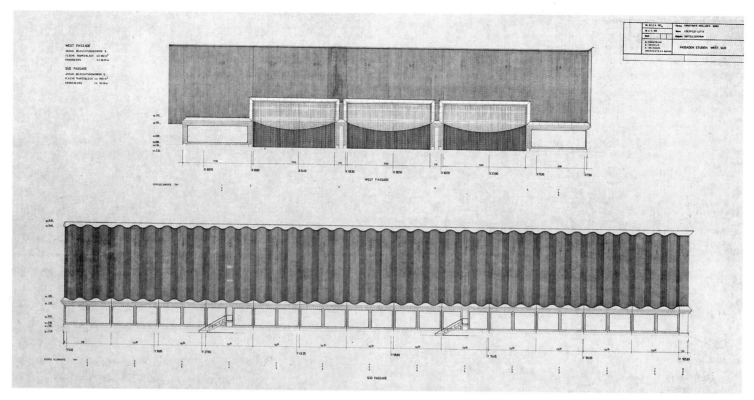

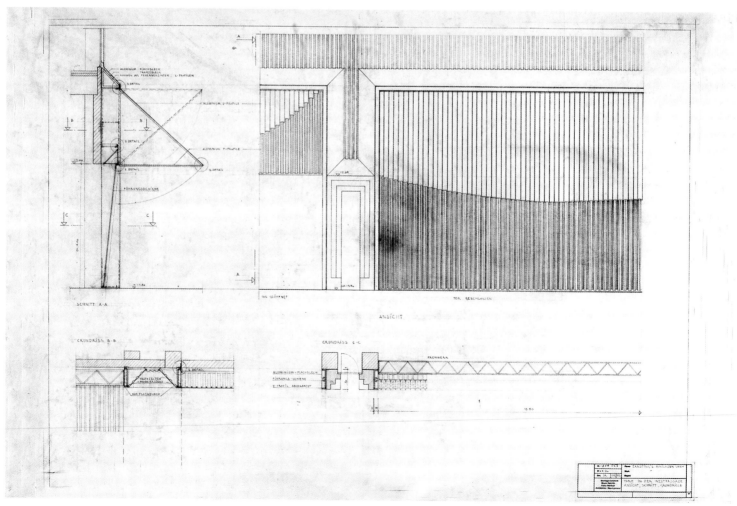

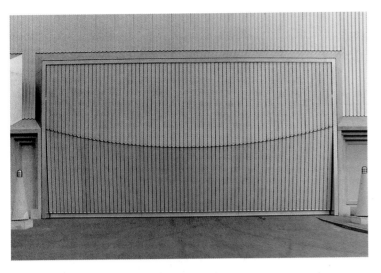 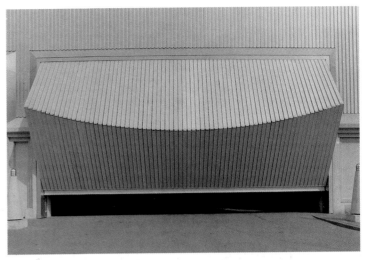

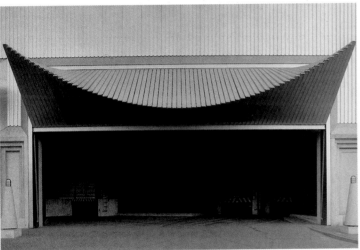 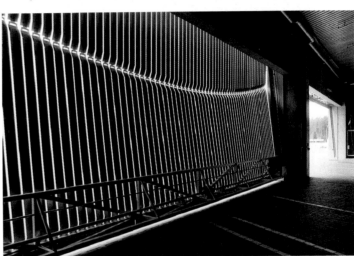

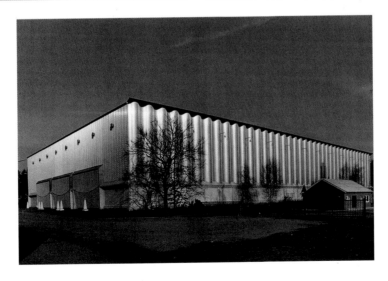

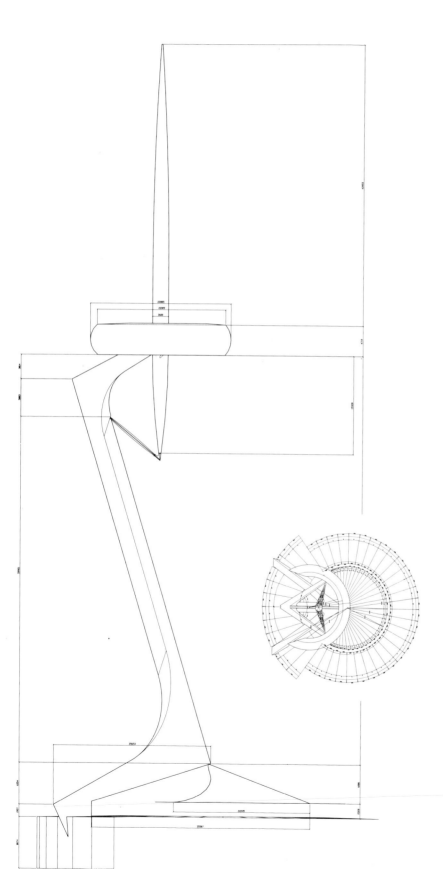

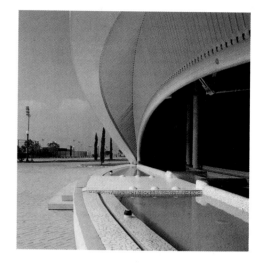

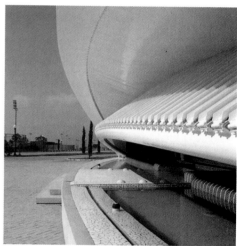

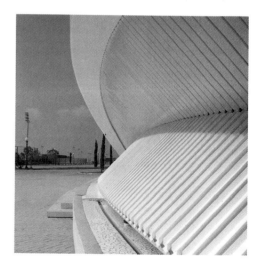

Shelter, San Gallo, 1989 (page 27)

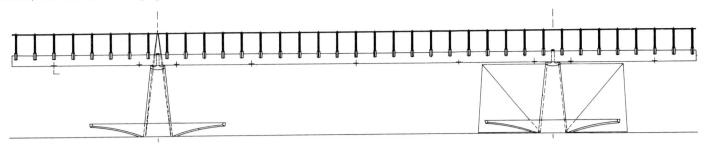

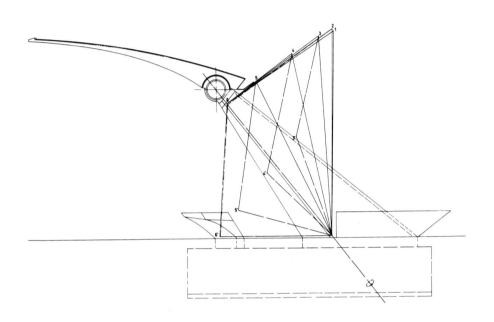

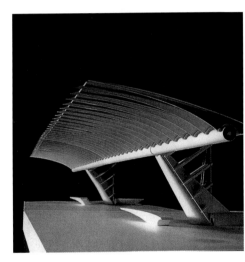

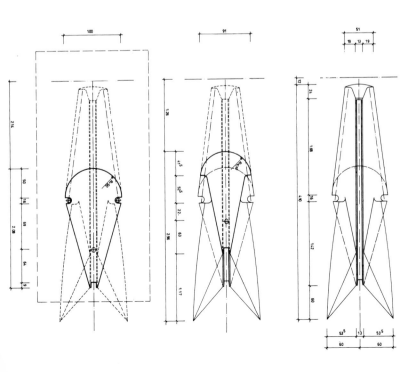

Plaza and Fountain, Alcoy, 1992–95 (pages 19–20, 29–31)

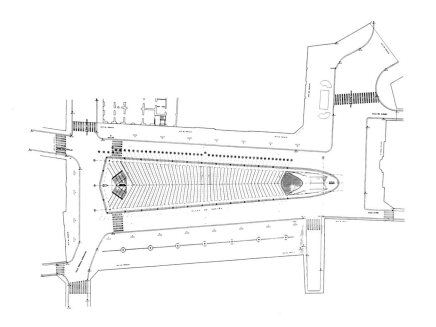

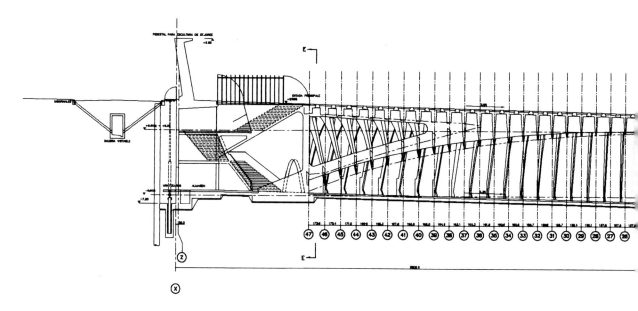

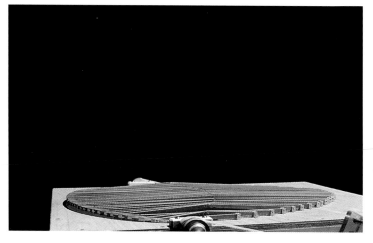

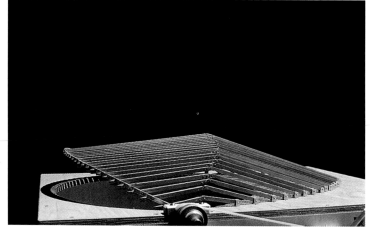

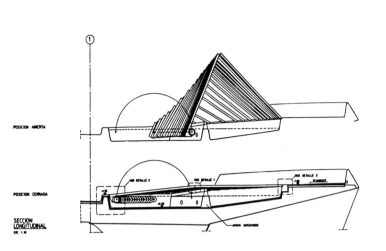

POSICION ABIERTA

POSICION CERRADA

SECCION
LONGITUDINAL
ESC 1:50

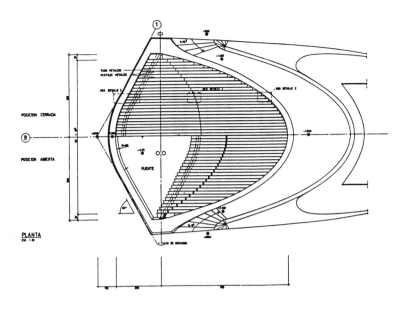

POSICION CERRADA

POSICION ABIERTA

PUENTE

PLANTA
ESC 1:50

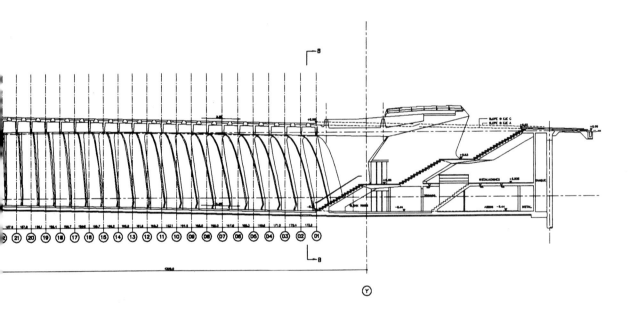

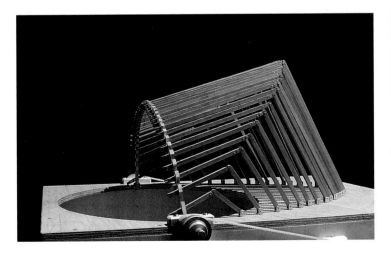

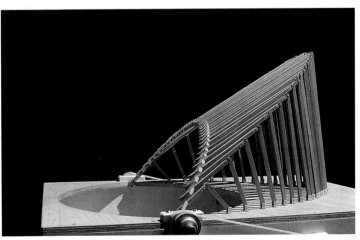

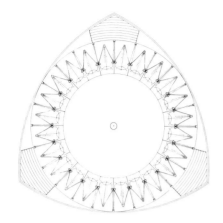

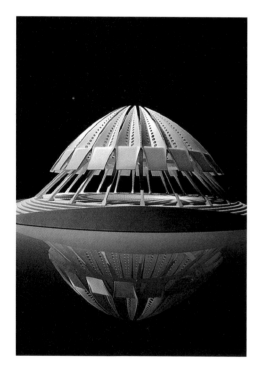

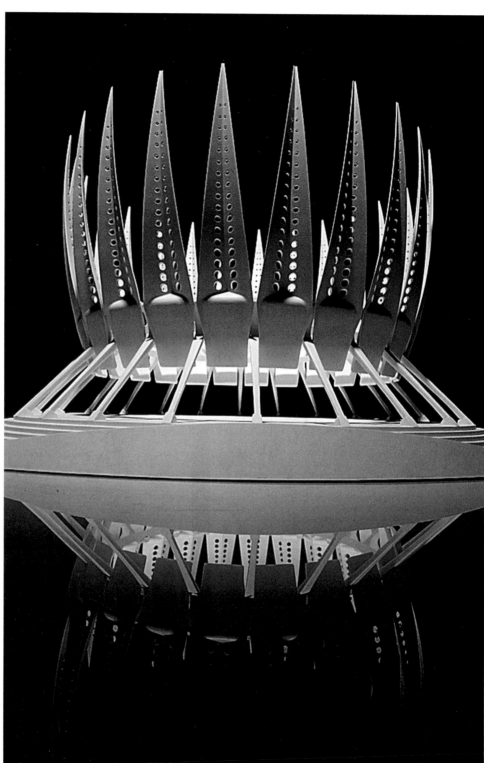

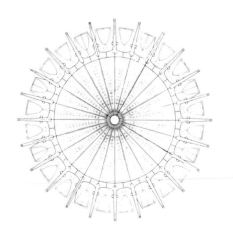

Pavilion on an Island, Zurich, 1988 (page 41)

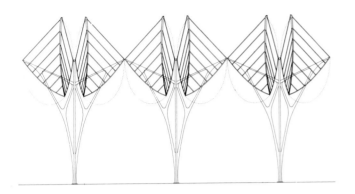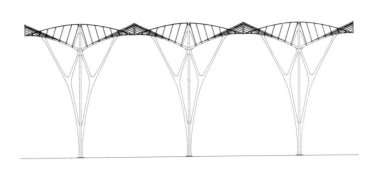

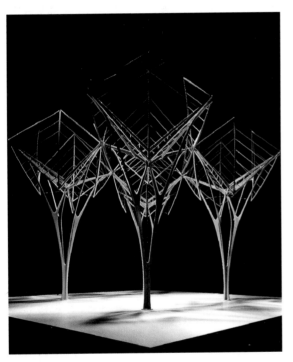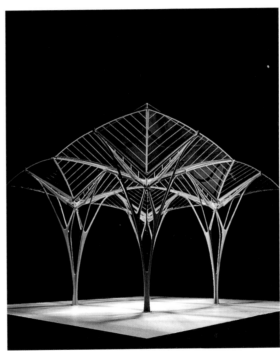

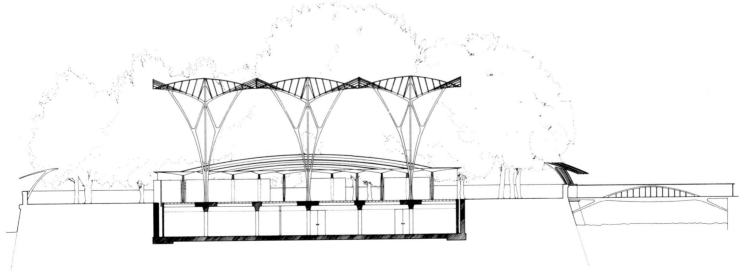

Kuwait Pavilion, Expo '92, Seville, 1991–92 (pages 13, 34)

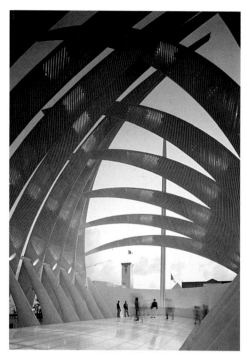

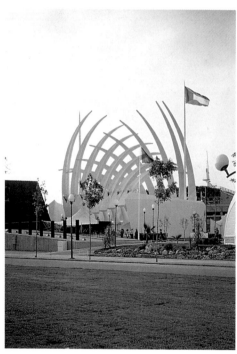

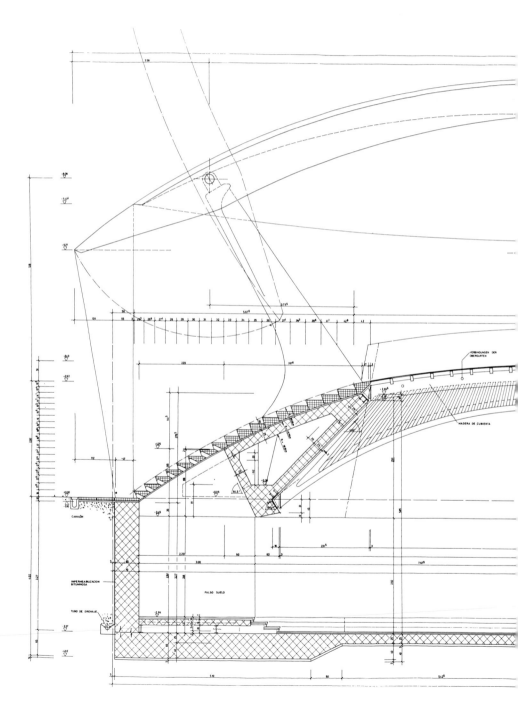

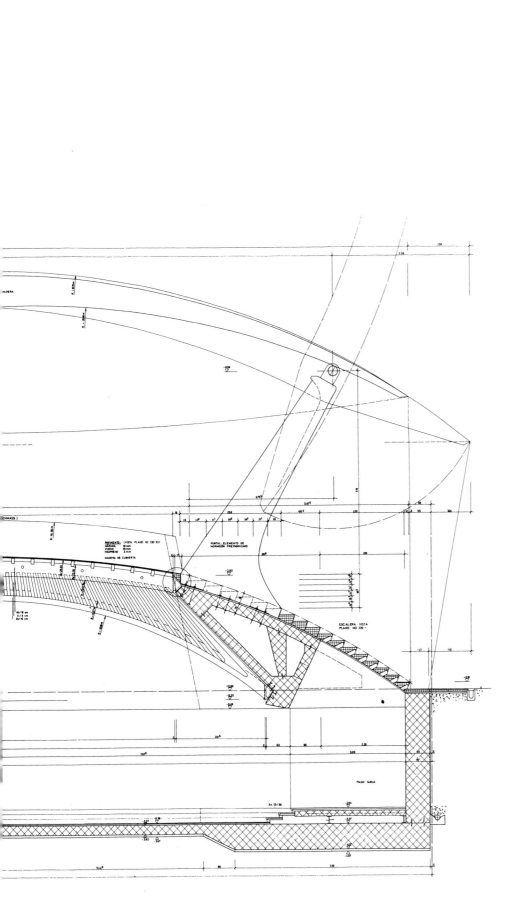

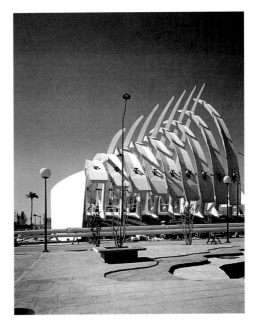

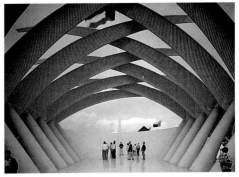

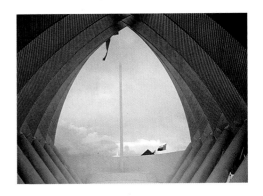

71

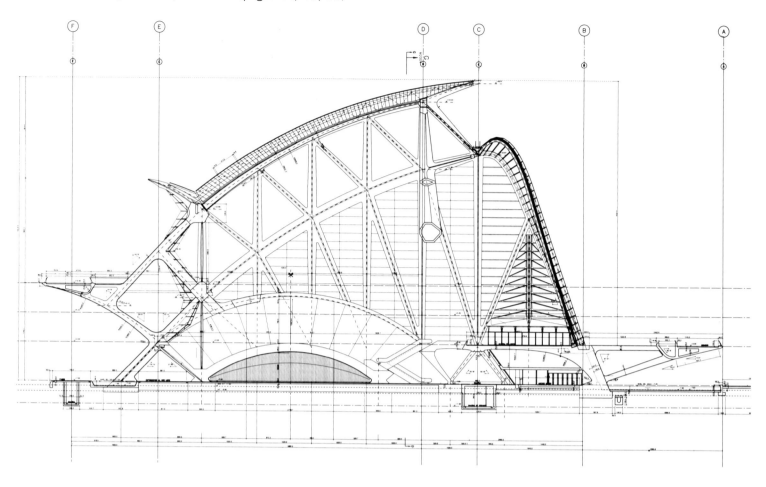

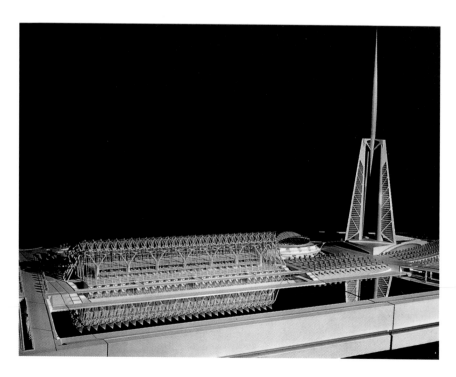

Planetarium, Valencia, 1991–95 (pages 21–22)

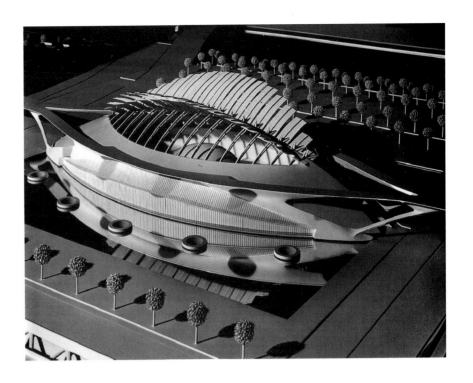

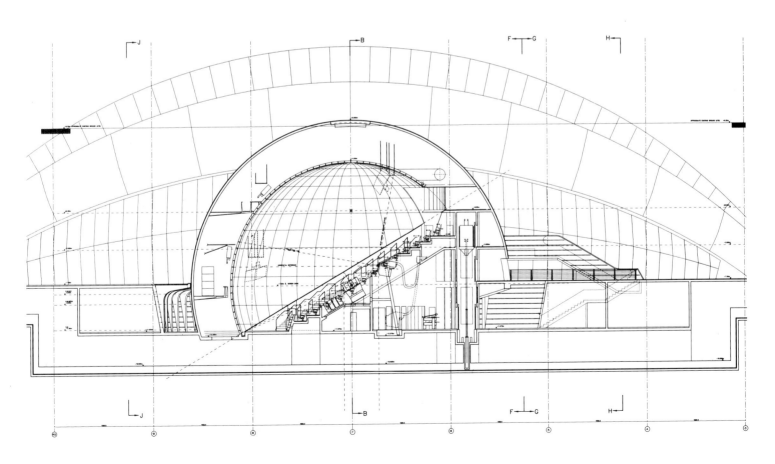

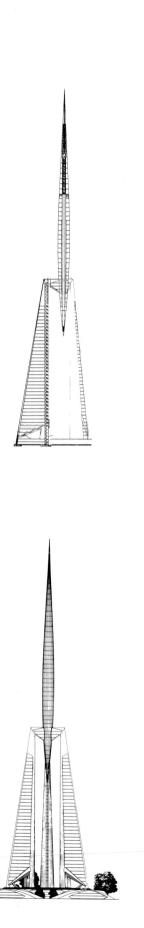

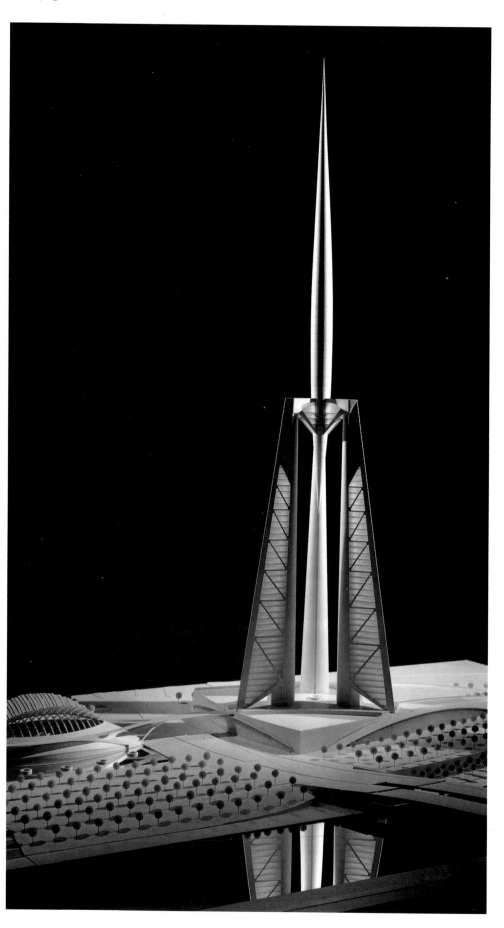

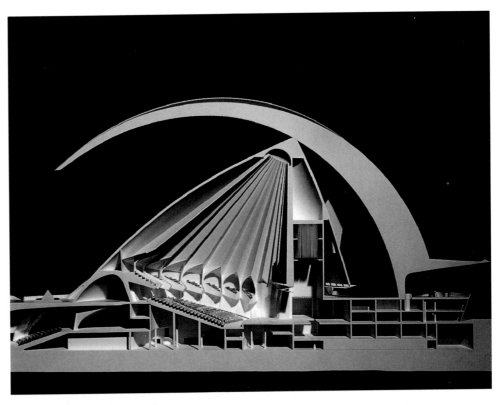

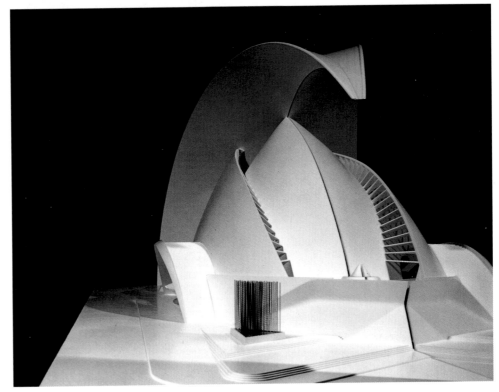

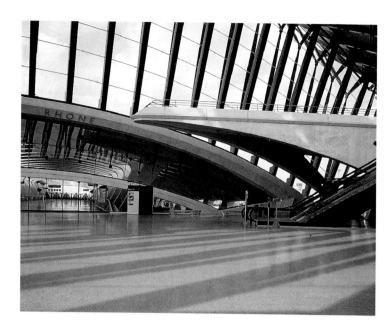

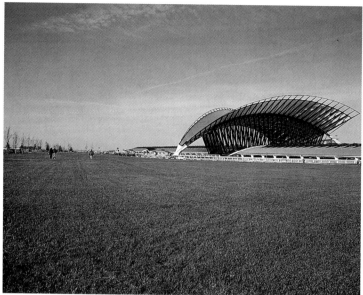

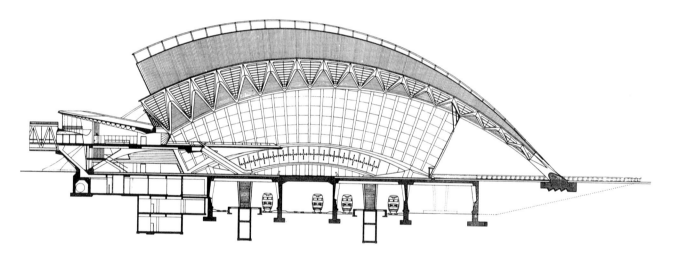

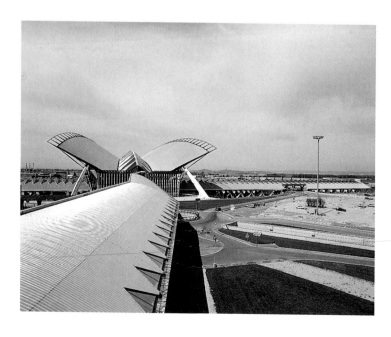

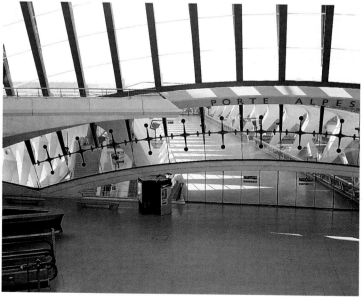

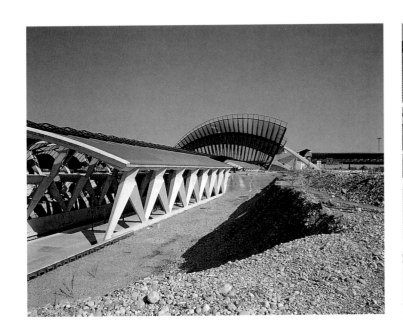
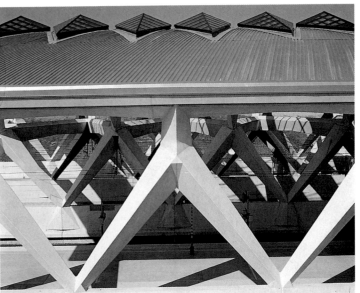
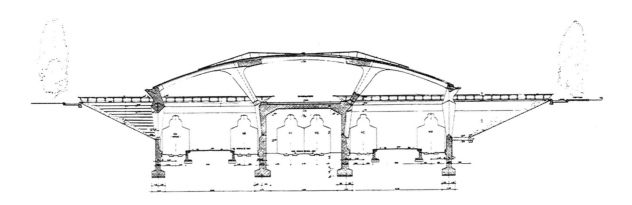
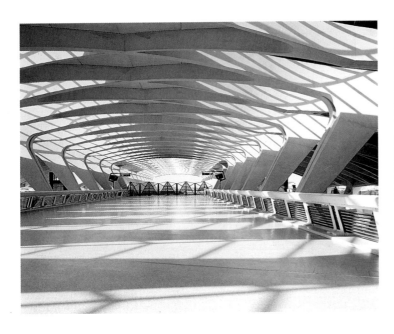
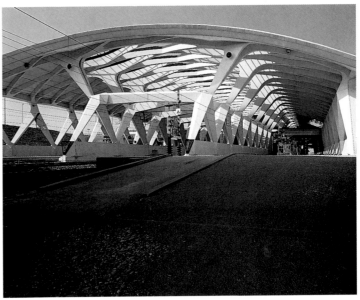

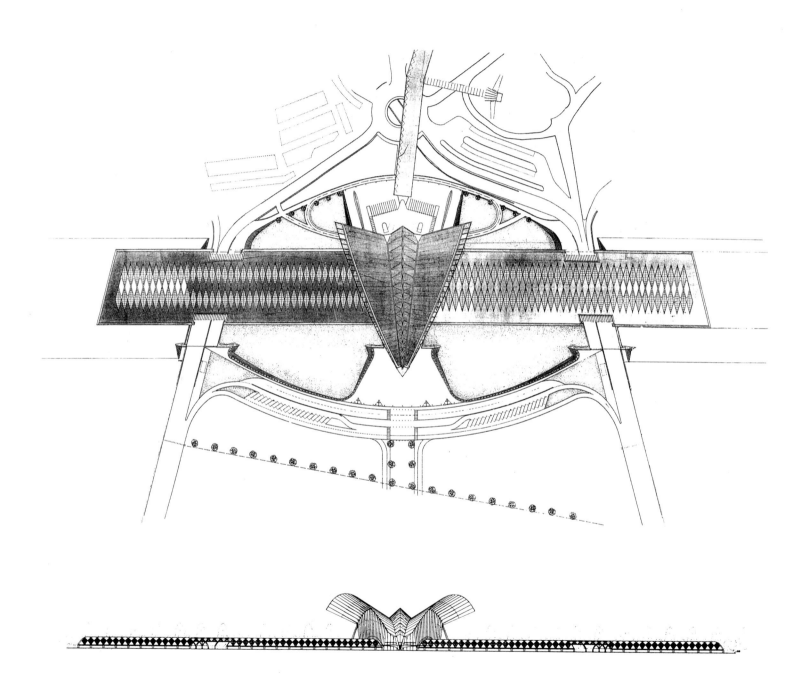

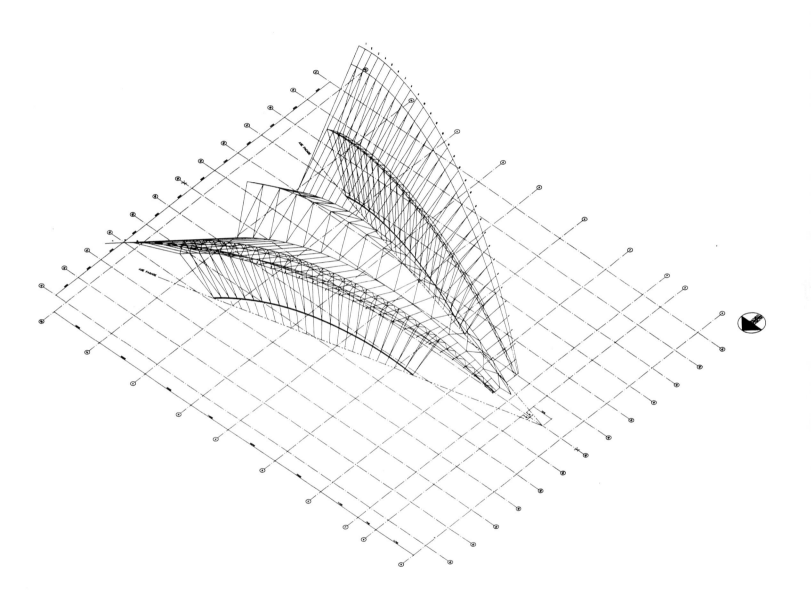

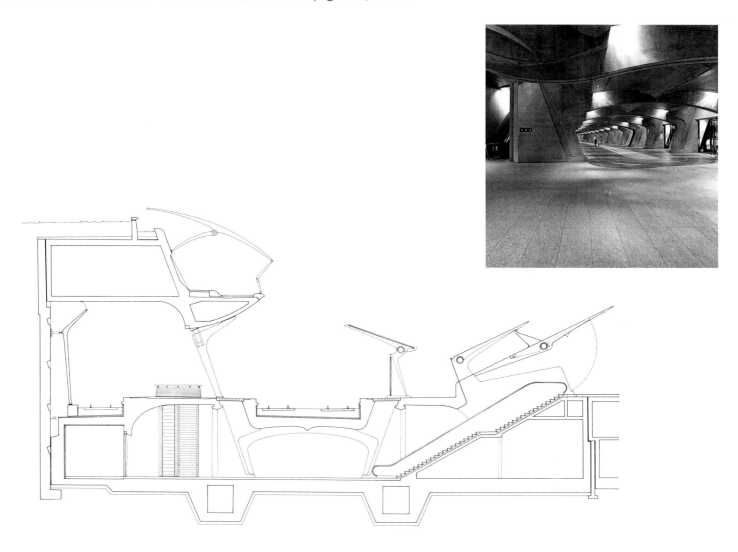

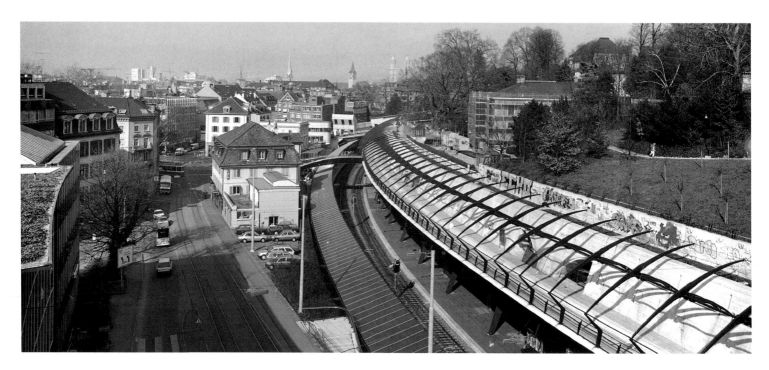

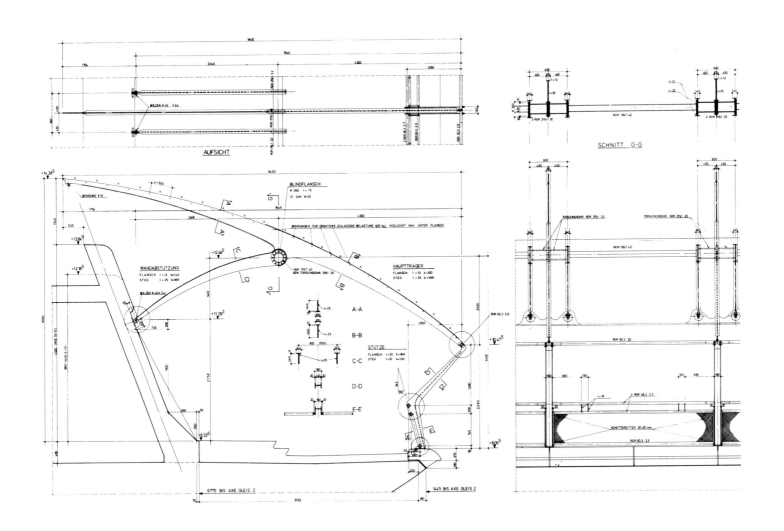

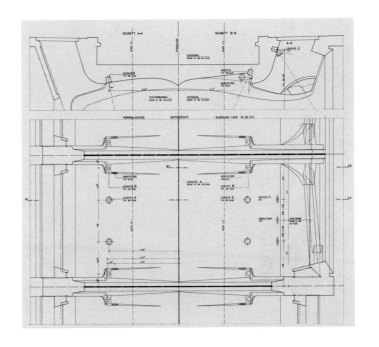

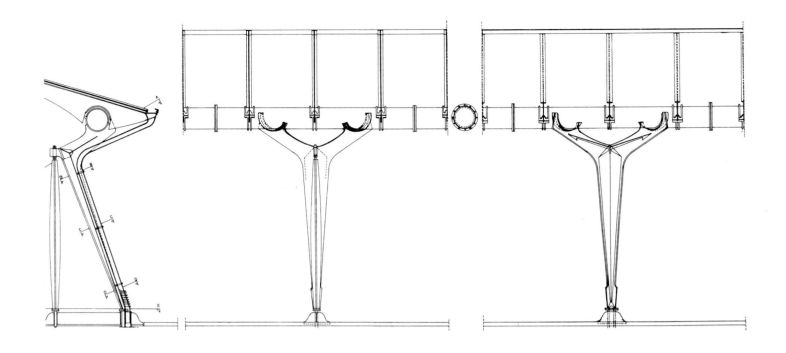

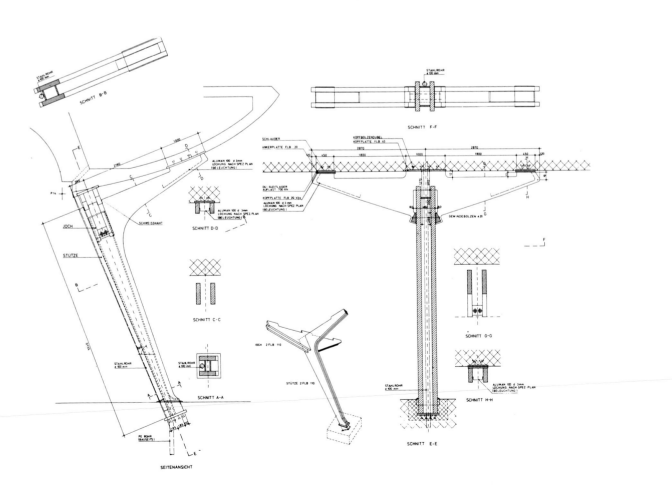

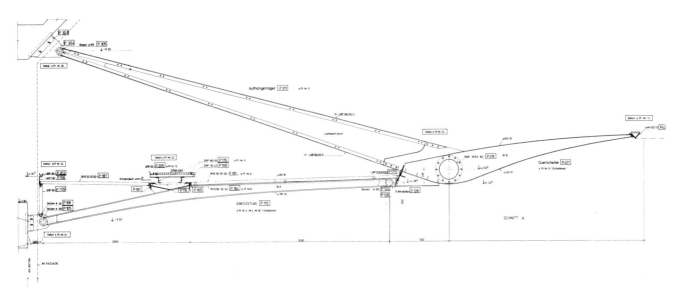

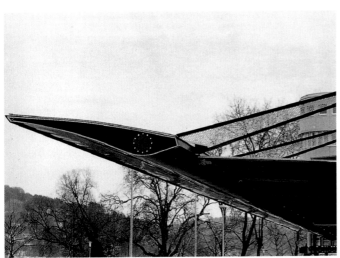

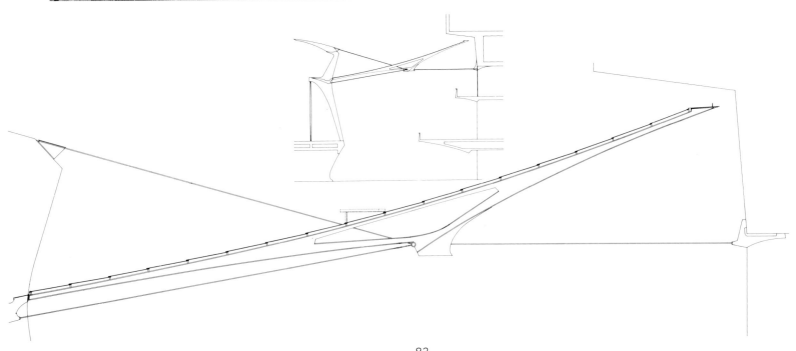

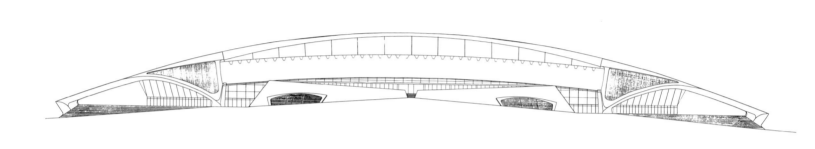

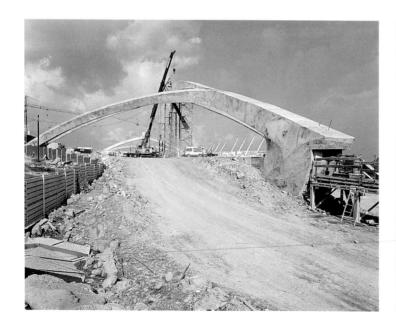

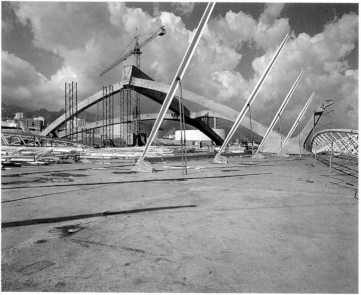

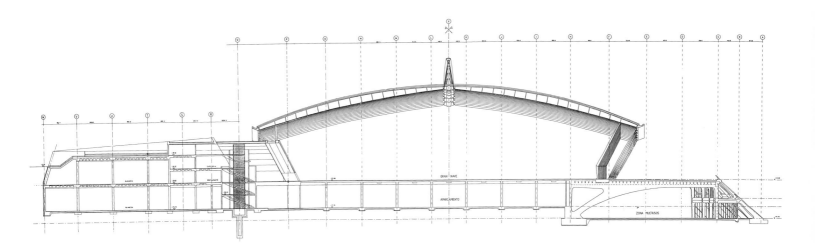

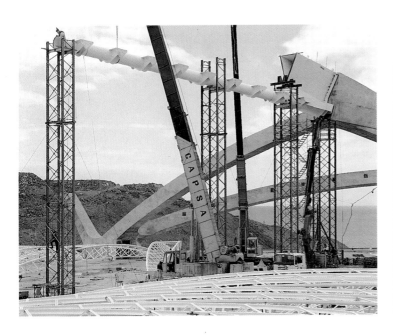

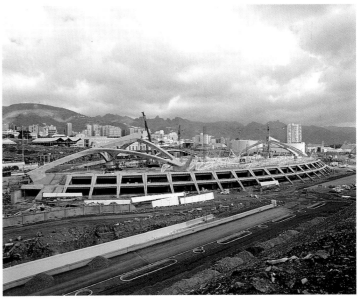

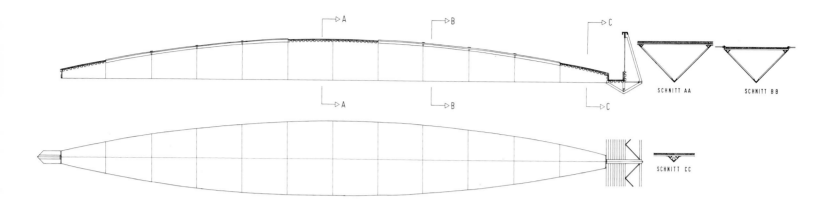

SCHNITT AA SCHNITT BB

SCHNITT CC

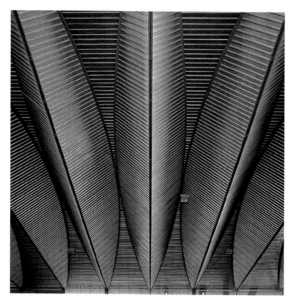

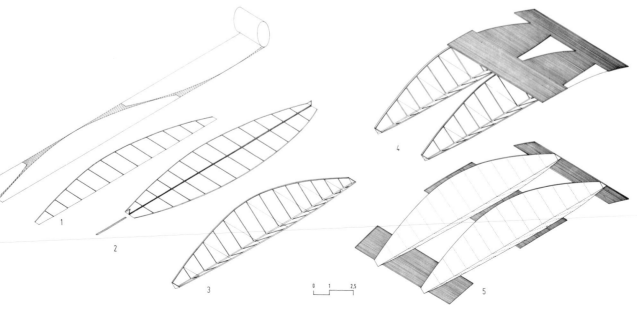

1

2

3

0 1 2,5

4

5

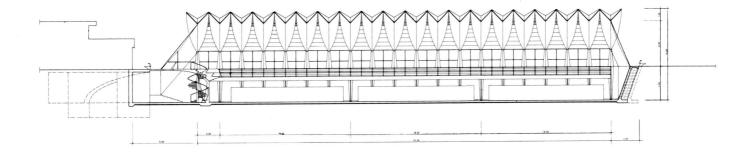

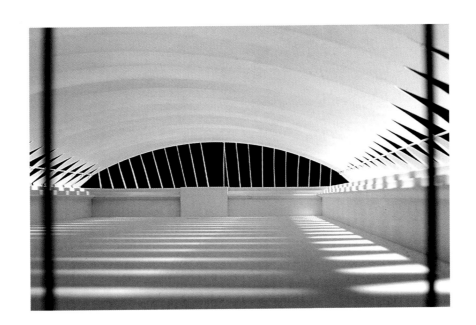

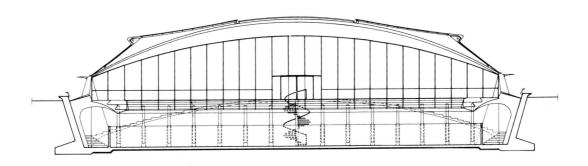

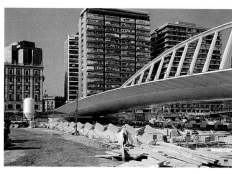

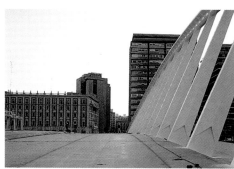

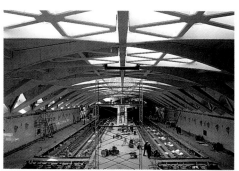

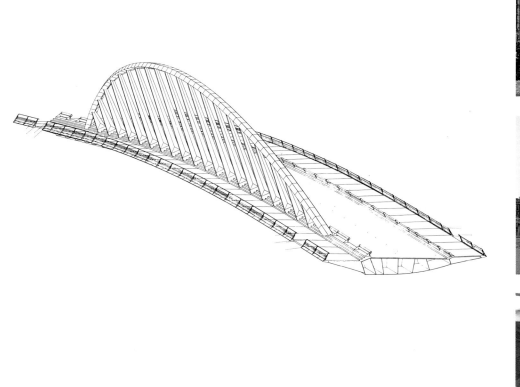

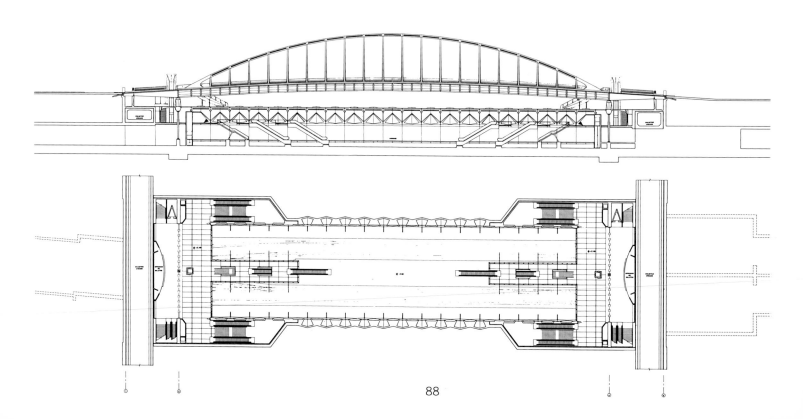

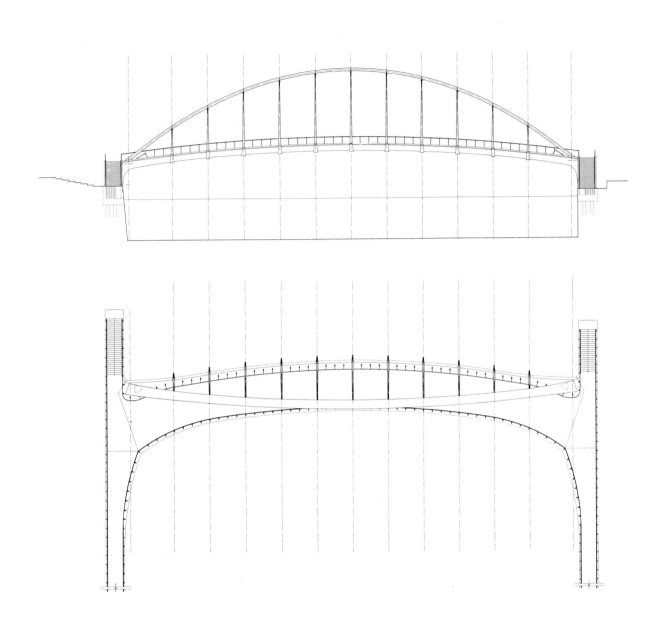

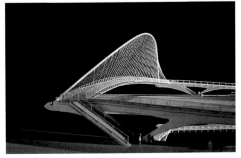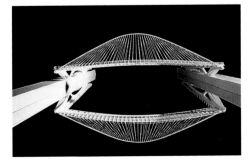

Bach de Roda Bridge, Barcelona, 1984–87 (page 48)

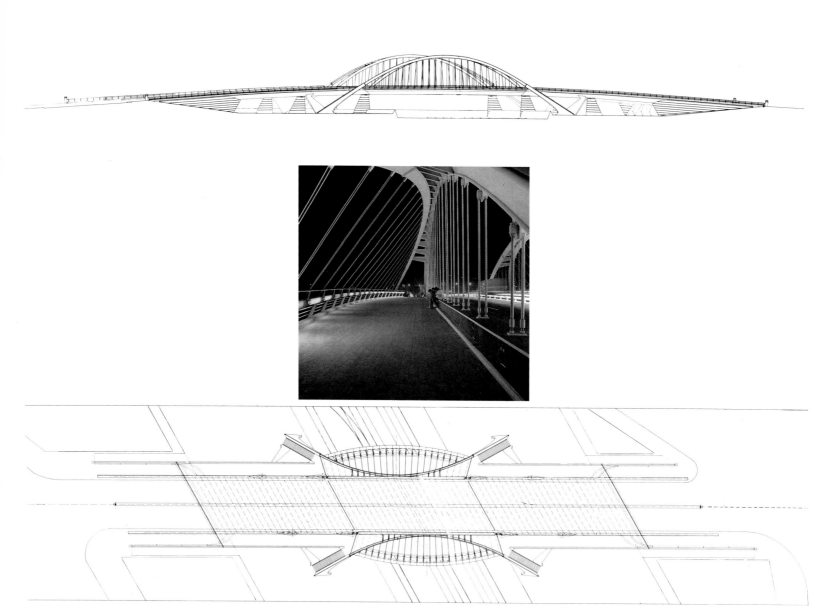

Gran Via Bridge, Barcelona, 1989 (page 46)

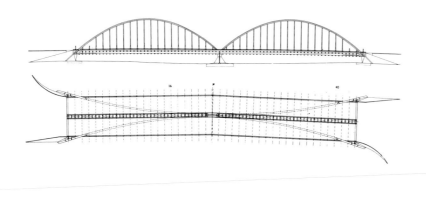

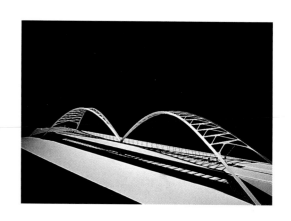

Ria Bridge, Ondarroa, 1989–94 (page 49)

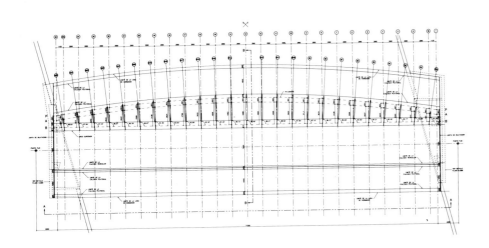

La Devesa Bridge, Ripoll, 1989–91 (page 49)

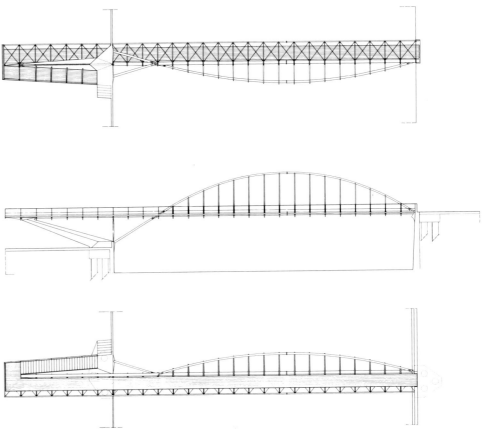

Alamillo Bridge, Seville, 1987–92 (page 54)

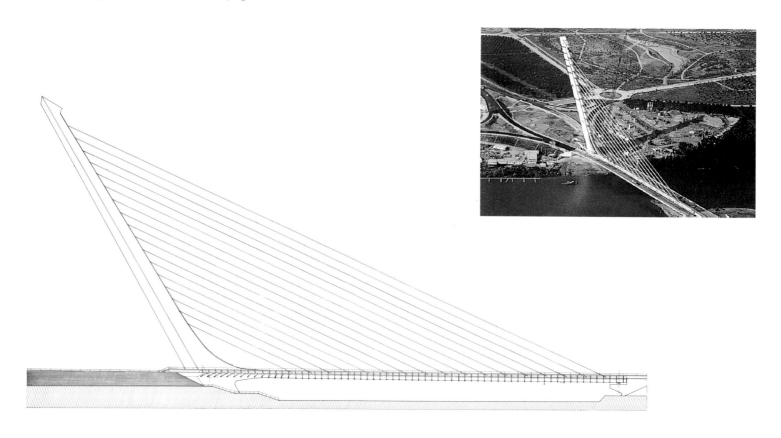

Lusitania Bridge, Merida, 1988–91 (pages 48, 49)

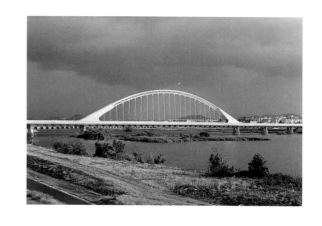

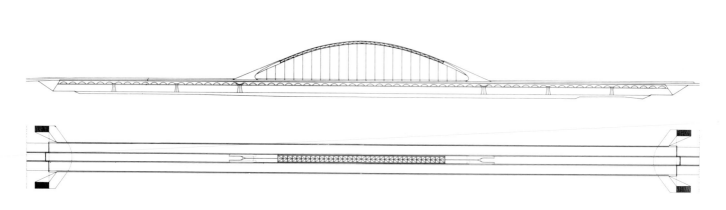

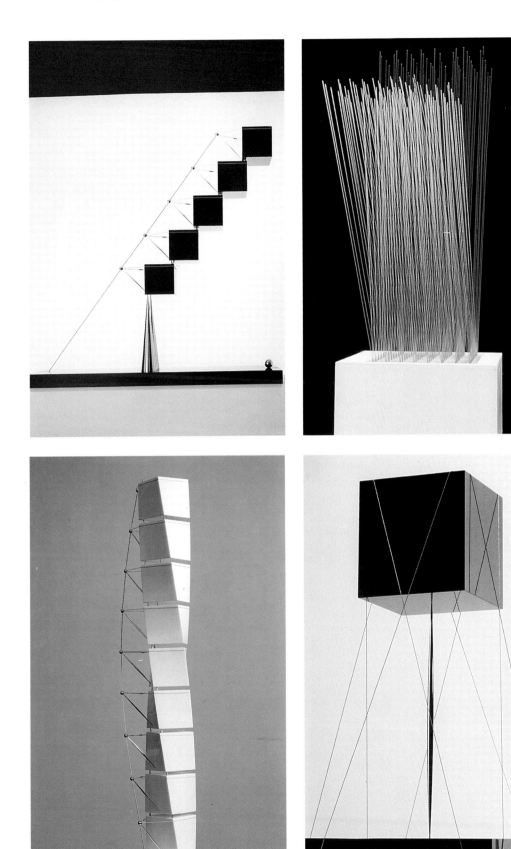

Santiago Calatrava

Born on July 28, 1951, in Benimamet, near Valencia, he attended the Art School in Valencia from 1968 to 1969 and graduated from the university there in 1974 with a degree in architecture. From 1975 to 1979 he studied civil engineering at the Federal Polytechnic in Zurich, where he obtained a Ph.D. in technical science in 1981 with a thesis entitled "Concerning the Foldability of Spaceframes." In the same year he opened an architectural and engineering office in Zurich; in 1989 he opened a second office in Paris.

He has participated in numerous competitions in Europe and America; most of his built work is in Switzerland, Germany, France, Spain, and Canada. Many exhibitions have been dedicated to his work in both architecture and sculpture: in Basel, Chicago, Los Angeles, Toronto, Montreal, Helsinki, Zurich, Stockholm, Copenhagen, Valencia, London, New York (Museum of Modern Art), Tokyo, Lisbon, and Venice.

Among the awards he has received are the August Perret UIA prize, Paris, 1987; the Fritz Schumacher prize, Hamburg, 1988; the Fazlur Rahaman Khan International Fellowship, 1988; and the Gold Medal of the Institute of Structural Engineers, London, 1992.

Many publications have been dedicated to his work in the past few years after the first monograph by Pierluigi Nicolin, "Santiago Calatrava: Il folle volo," *Quaderni di Lotus 7,* 1987, including Calatrava's own *Dynamische Gleichgewichte: Neue Projekte* (Zurich, 1992); Robert Harbison and Paolo Rosselli, *Creatures from the Mind of the Engineer: The Architecture of Santiago Calatrava* (Zurich, 1992); Kenneth Frampton, *Calatrava Bridges* (Zurich, 1993); "Santiago Calatrava," *El Croquis,* 1993; Bernhard Klein, *Santiago Calatrava: Bahnhof Stadelhofen, Zurich* (Zurich, 1993); and Michael S. Cullen, *Calatrava Berlin: Five Projects* (Basel, 1994).

Works

Sports Pavilion, Berlin 1980 (project)
Jakem Factory, Munchwilen Switzerland 1983-84
Ernsting Factory, Coesfeld Germany 1983-85
Stadelhofen Station, Zurich 1983-90
Post Office, awnings, Lucerne 1983-85
Station, entrance hall, Lucerne 1983-89
Bach de Roda Bridge, Barcelona 1984-87
Alamillo Bridge, Seville 1987-92
Sports Center, Geneva 1988 (project)
Pavilion on a Lake, Bauschänzly Restaurant, Zurich 1988 (project)
Lusitania Bridge, Merida 1988-91
Shelter, San Gallo 1989 (project)
Pavilion, Swissbau 89, Basel 1989
Floating Pavilion, Expo Switzerland 91 Lake Lucerne 1989 (project)
Gran Via Bridge, Barcelona 1989 (project)
La Devesa Bridge, Ripoll Spain 1989-91
Telecommunication Tower, Montjuic, Barcelona 1989-92
Satolas Station, Lyon 1989-94
Ria Bridge, Ondarroa Spain 1989-94
Campo Volantin Bridge, Bilbao 1990 (project)
Auditorium, Santa Cruz de Tenerife, Spain 1991 (project)
Kuwait Pavilion, Expo 92, Seville 1991-92
Science Museum, Valencia 1991-95 (project)
Planetarium, Valencia 1991-95 (project)
Telecommunication Tower, Valencia 1991-5 (project)
Alameda Bridge and Station, Valencia 1991-5
Exhibition Building, Tenerife Spain 1992-95
Plaza and Fountain, Alcoy Spain 1992-95
Sculpture, MOMA, New York 1993